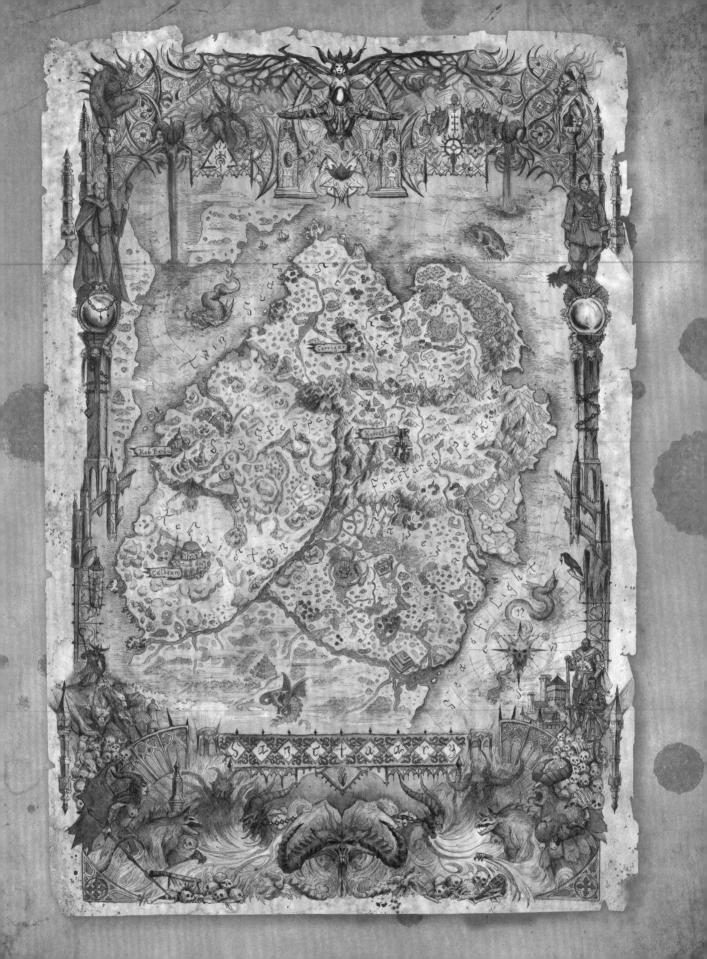

DIABLO®

BOOK OF LORATH

Written by Matthew J. Kirby

BLIZZARD
ENTERTAINMENT

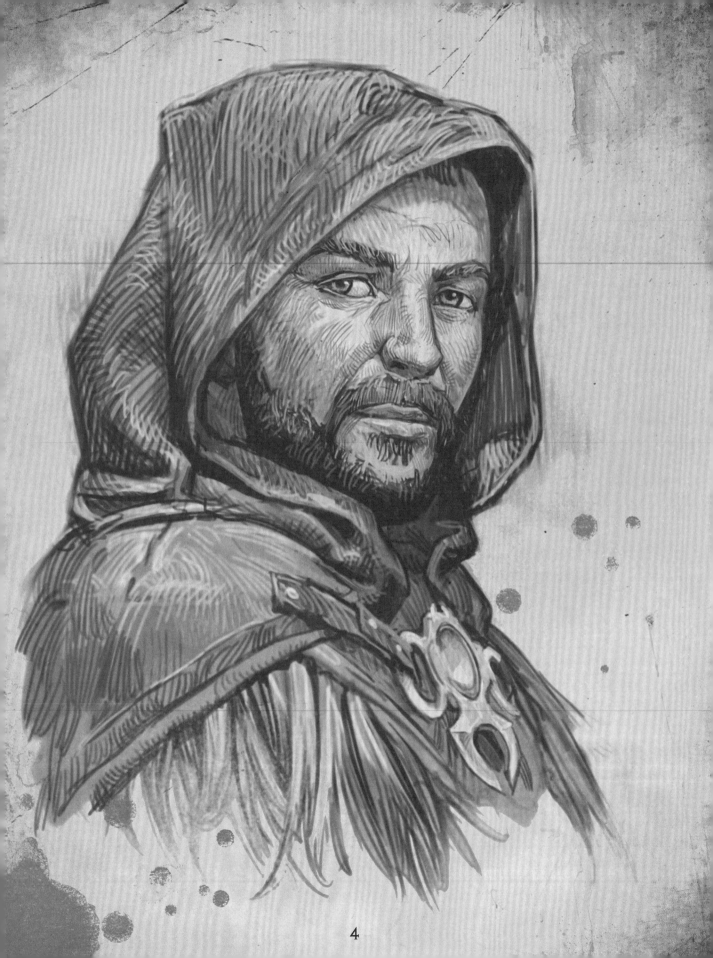

Take Heed

This book should not exist.
And yet, this book __must__ exist.

When I, Lorath Nahr, consider the history of the Horadric Order to which I have belonged, I feel both pride and shame. As a younger man, I dreamed of joining them, even against my father's wishes. He was a soldier and a blacksmith who worked with the hard material of the world at hand. He had little use for ancient knowledge and scholarly tomes. But I admired the Horadrim for their courage, their power, and for what I believed to be wisdom. I trusted in their goodness.

That was a long time ago, and I am now an old man with more scars than I can count. Each one aches from my many years, yet it is the invisible scars that bend my back the most. In the darkest moments of my despair, I have sometimes thought of my father hammering away in the red heat of his forge and wished that I had taken the path he wanted for me. For the Horadrim have not always been wise. Some even turned toward the very evil they had sworn to fight. Nor have I always been wise. ~~I have made mistakes, terrible mistakes that~~

It is possible that my name will be remembered in infamy and I will be spoken of in whispers reserved for the damned. If that should be the case, I cannot object to it. Had I been more observant, had I been stronger, had I seen the betrayal to come, Donan might still be alive. Instead, I sit here in his study, surrounded by his possessions, writing this book.

Some might rightly question how I can risk creating such a volume, knowing as I do now that not even my fellow Horadrim can be trusted with the knowledge I intend to write in its pages. But I see no other way. The Cathedral of Light has seized the Vault, and I don't know what will be left when they are through. The need for this record, therefore, outweighs the danger it represents, even if it were to fall into the wrong hands.

So I write this book for your sake, you who are reading my words. In these pages, you will find a catalog of the many powerful relics scattered and hidden throughout Sanctuary, from the seemingly mundane to the extraordinary. Some objects described herein are imbued with the light of angels, while others burn with the hellfire of demons. Some are weapons, and some are symbols of peace. Some no longer exist, except as memories and ideas. But never forget that all are perilous, each in its own way. I give you this knowledge to arm you for the fight that is undoubtedly before you. That way, when evil finds a foothold and flourishes once again, at least I can say it will not be due to ignorance. That is why this book must exist.

It will be up to those who come after me to decide what the Horadric Order might yet become, broken as it is, or if it is to go on existing at all. Perhaps it will rise once more to its former stature and be again what I admired in my youth. Alas, I will leave such dreams to more hopeful souls than mine. The events of my life have taught me well that evil is inevitable and can never be truly destroyed. It can be banished. It can be thwarted. It can be driven back, but only for a time. I have come to accept that we humans are merely battlefield fodder, trapped between the High Heavens and the Burning Hells in their Eternal Conflict.

There is no escaping this fate.

But I am not a fool, and I will not leave the knowledge in this book unguarded. Recent events have shown me that Horadric codes and ciphers are insufficient when the enemy might come from within our ranks. I have therefore devised new protections. My plan will require a lengthy journey, which I shall undertake as I write, trusting that I will see its conclusion before I die. But I am old, and the road is long.

So let us begin.

Neyrelle,

Fate willing, this book has found its way into your hands, and I hope to be the one who put it there. I write it for you more than anyone else, despite the terrible burden you carry. I know why you have chosen your dark path, and you must follow it where it leads. That is true for all of us. Once, I might have tried to choose your path for you, but no more. You are as aware of my failures in that as anyone, and we both know you wouldn't have listened to me. But I have faith in your goodness, and I pray your strength will prevail against the evil you hold. May our paths cross at least once more. Take care, child.

Lorath

Elias's Finger & Tattoo Chisel

As I sit here in Donan's study, I suppose it is only right that the first relic in this book should be a reminder of my greatest failure. It is one of Elias's fingers (or what remains of it). He severed it during a blasphemous ritual in the Sunken Temple of the Deathspeaker in Hawezar.

Elias was a brilliant pupil, a mage of great talent and promise, and in him I once believed I glimpsed the future of the Horadrim. I did not see the darkness that lurked behind his ambition. I was blind to the signs of his capacity for treachery and evil. But I should have seen these things. If I had been a better, wiser teacher, perhaps he would have found a different path. If I had offered him the great purpose he craved, perhaps I would not be here now, holding these charred bones.

Elias exchanged this piece of his body for immortality. Had we not discovered it, at great personal cost, he would have been unstoppable in his service to the demon Lilith, Daughter of Hatred, an outcome I shudder to contemplate. In the end, he was defeated, and I am left with this relic of his sins. *and mine* I do not know what purpose these bone fragments could be put to. I fear they hold a residue of evil and could yet be the cause of future mischief and suffering.

we will come to that in subsequent pages

This cruel implement now tortures my mind as it once did flesh. Of the many depravities committed by Elias, I am perhaps most haunted by the ritual he attempted to perform on a witch named Taissa, a profane sacrifice that would have allowed Andariel, Maiden of Anguish, to return to Sanctuary. I sometimes hear Taissa's screaming in my dreams, only this time I cannot save her as I did in the waking world. I cannot stop Elias from carving into her, and I must listen to her agony as I frantically search in vain. The chisel is made of heavy iron, and its cutting edge is still gleaming and sharp. Though its shape is simple, there is no grace in its line or form. I have cleaned it, and yet it retains a stain that is not rust. Its bloody inquest imprinted it with the very substance it sought, and this chisel drank deep from the blood of those it violated.

Clear skies today, so went walking with Braega and Yorin up in the hills above the house. Wildflowers grew all around, which delighted B. She gathered a bouquet as we went—some for fragrance, others for cooking and medicine.

Yorin's mind was only half with us, the other part riding high on imagined adventures and triumphs. Like many his age, he desires to be tested, and that is what worries me. I would keep him with me forever if I could, protected and safe, but he is almost a grown man, with his own life to lead. I cannot hold him back much longer.

We passed the day in leisure and joy in each other's company. Finished the evening with a meal and songs. B and Y are in bed now, and their sleep is peaceful. Mine is not. No matter how clear the skies, a cloud hangs over the back of my mind at all times. I cannot forget the evil that lies imprisoned beneath the keep, and I fear what will happen if it is ever set free. This dread has come to torment both my waking hours and my dreams of late. The only rest I find comes from my faith in the Light. Inarius will protect us. After all, I would do anything for my child. I would gladly lay down my life to save his. And are we not the children of Inarius?

Donan's Journals

I did not know Donan well. He was a fellow Horadrim, but other than that commonality, we shared few similarities, either in temperament or philosophy. Though we respected each other as colleagues, I cannot claim to have called him a friend for most of the years I knew him, nor would he have described me as such, until perhaps at the end.

Now he is gone, slain in the depths of Hell, and I sit here in his study, reading from his journals. They are bound in tooled leather worn smooth and almost glossy from frequent handling, and they smell faintly of dried herbs, woodsmoke, and the damp heath that covers much of Scosglen. Some of his writings are of a personal nature, rendered poignant and haunting by his death.

Much of his work, however, is scholarly and quite brilliant. These pages remind me of the reasons for the intellectual distance between us, though I am no longer as irritated by our familiar disagreements. In fact, I rather wish that he were here to tell me once again how my ideas are utter bollocks, and then we could go on bickering over his blind and unwavering faith.

Two things are clear from his journals: Firstly, he possessed a keen and observant mind, and I will gratefully make use of the rich lore his journals contain to fill the gaps in my own recollections. Secondly, he loved his wife and son dearly. I have never married, but I did once love As I read about Donan's life with Braega, I confess to twinges of envy, the wistful regret of an old man revisiting missed opportunities, wondering what might have been.

Grimoire of Ash

In Donan's study, locked away in a small corner chest, I found something unusual. It is a book, notable not only for the fact that someone apparently tried to hide it but also because it seems that someone tried to <u>burn</u> it. The leather binding and many of its pages are caked with soot that I cannot brush or wipe away. I cannot say with certainty what might be written beneath the ash on these pages. The few markings that remain legible unsettle me, for they describe certain places in the Burning Hells as if by one who has seen them and yearns to return.

I am troubled by the fact that someone tried to destroy this book with fire. That it survived the flames intact causes me dread. There is magic upon it, and I cannot discern whether it is blessed or cursed. I suspect the latter. Its unremarkable size and weight and lack of decoration somehow only add to its sinister qualities.

The Realm of Hatred, the glory of Mephisto, touches every grain of sand and drop of blood. Sublime hymns of loathing are carried on the wind there, and at its center stands the Citadel of Hatred, the bastion of its lord. All who stand before its gates cower, overcome by its terrible majesty.

Light a candle,
Cast a
shadow.
Kindle a fire,
Darken the
night.

A common saying in the Western Kingdoms and elsewhere, which I have heard repeated many times. I see the Eternal Conflict raging behind these few words.

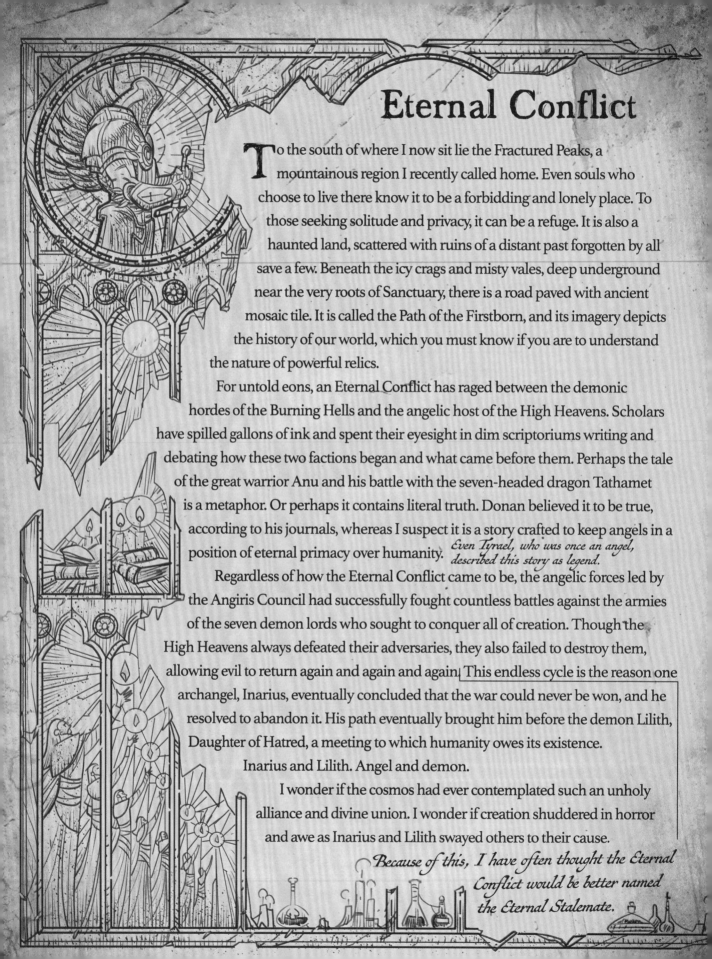

Eternal Conflict

To the south of where I now sit lie the Fractured Peaks, a mountainous region I recently called home. Even souls who choose to live there know it to be a forbidding and lonely place. To those seeking solitude and privacy, it can be a refuge. It is also a haunted land, scattered with ruins of a distant past forgotten by all save a few. Beneath the icy crags and misty vales, deep underground near the very roots of Sanctuary, there is a road paved with ancient mosaic tile. It is called the Path of the Firstborn, and its imagery depicts the history of our world, which you must know if you are to understand the nature of powerful relics.

For untold eons, an Eternal Conflict has raged between the demonic hordes of the Burning Hells and the angelic host of the High Heavens. Scholars have spilled gallons of ink and spent their eyesight in dim scriptoriums writing and debating how these two factions began and what came before them. Perhaps the tale of the great warrior Anu and his battle with the seven-headed dragon Tathamet is a metaphor. Or perhaps it contains literal truth. Donan believed it to be true, according to his journals, whereas I suspect it is a story crafted to keep angels in a position of eternal primacy over humanity. *Even Tyrael, who was once an angel, described this story as legend.*

Regardless of how the Eternal Conflict came to be, the angelic forces led by the Angiris Council had successfully fought countless battles against the armies of the seven demon lords who sought to conquer all of creation. Though the High Heavens always defeated their adversaries, they also failed to destroy them, allowing evil to return again and again and again. This endless cycle is the reason one archangel, Inarius, eventually concluded that the war could never be won, and he resolved to abandon it. His path eventually brought him before the demon Lilith, Daughter of Hatred, a meeting to which humanity owes its existence.

Inarius and Lilith. Angel and demon.

I wonder if the cosmos had ever contemplated such an unholy alliance and divine union. I wonder if creation shuddered in horror and awe as Inarius and Lilith swayed others to their cause.

Because of this, I have often thought the Eternal Conflict would be better named the Eternal Stalemate.

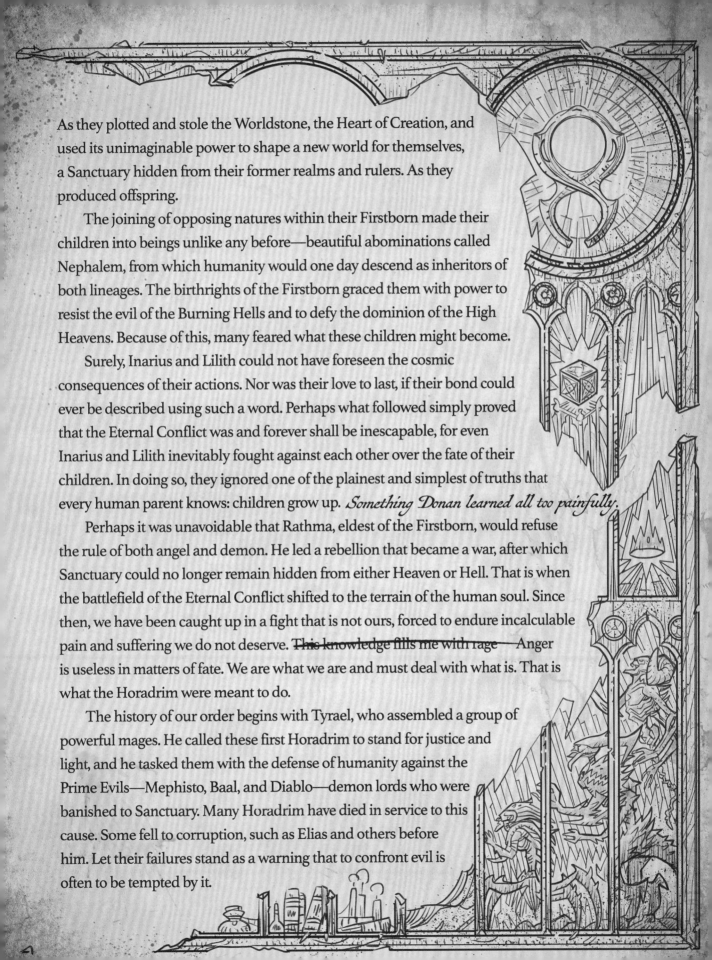

As they plotted and stole the Worldstone, the Heart of Creation, and used its unimaginable power to shape a new world for themselves, a Sanctuary hidden from their former realms and rulers. As they produced offspring.

The joining of opposing natures within their Firstborn made their children into beings unlike any before—beautiful abominations called Nephalem, from which humanity would one day descend as inheritors of both lineages. The birthrights of the Firstborn graced them with power to resist the evil of the Burning Hells and to defy the dominion of the High Heavens. Because of this, many feared what these children might become.

Surely, Inarius and Lilith could not have foreseen the cosmic consequences of their actions. Nor was their love to last, if their bond could ever be described using such a word. Perhaps what followed simply proved that the Eternal Conflict was and forever shall be inescapable, for even Inarius and Lilith inevitably fought against each other over the fate of their children. In doing so, they ignored one of the plainest and simplest of truths that every human parent knows: children grow up. *Something Donan learned all too painfully.*

Perhaps it was unavoidable that Rathma, eldest of the Firstborn, would refuse the rule of both angel and demon. He led a rebellion that became a war, after which Sanctuary could no longer remain hidden from either Heaven or Hell. That is when the battlefield of the Eternal Conflict shifted to the terrain of the human soul. Since then, we have been caught up in a fight that is not ours, forced to endure incalculable pain and suffering we do not deserve. ~~This knowledge fills me with rage~~ Anger is useless in matters of fate. We are what we are and must deal with what is. That is what the Horadrim were meant to do.

The history of our order begins with Tyrael, who assembled a group of powerful mages. He called these first Horadrim to stand for justice and light, and he tasked them with the defense of humanity against the Prime Evils—Mephisto, Baal, and Diablo—demon lords who were banished to Sanctuary. Many Horadrim have died in service to this cause. Some fell to corruption, such as Elias and others before him. Let their failures stand as a warning that to confront evil is often to be tempted by it.

Soulstones

It is said that the Worldstone used to create Sanctuary was once the eye of the great warrior Anu. It was from this mountain-size gem that Tyrael carved the first Soulstones, crystalline prisons for binding and restraining evil spirits, including demons. Donan's journals reflect his curiosity about Soulstones, but ~~I think he showed foolish~~ Without wishing to impugn Donan's reputation, I do believe he was naive in this matter, as he himself learned. Whether we are discussing the first Soulstones given to the Horadrim by Tyrael or later examples fashioned by mortal hands, I believe they are all dangerous.

Tyrael once had a lieutenant, an angel named Izual, who fell to Hell's corruption. Izual claimed to have revealed the nature of the Soulstones to the Prime Evils, a betrayal that essentially handed over the keys of the prison to the prisoners. That is why I cannot put my faith or trust in Soulstones. They will never offer more than the temporary illusion of control over the powers of Hell. And Hell should never be underestimated.

including the latest innovation of the Helliquary

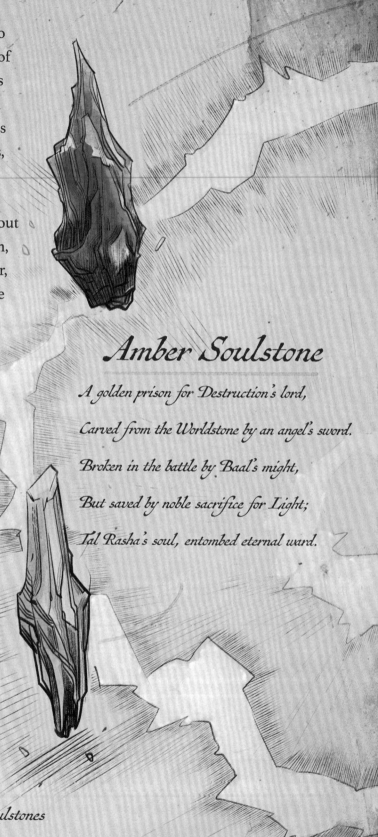

Amber Soulstone

A golden prison for Destruction's lord,

Carved from the Worldstone by an angel's sword.

Broken in the battle by Baal's might,

But saved by noble sacrifice for Light;

Tal Rasha's soul, entombed eternal ward.

I admit that much of my hatred of Soulstones comes from my fears for you, Neyrelle.

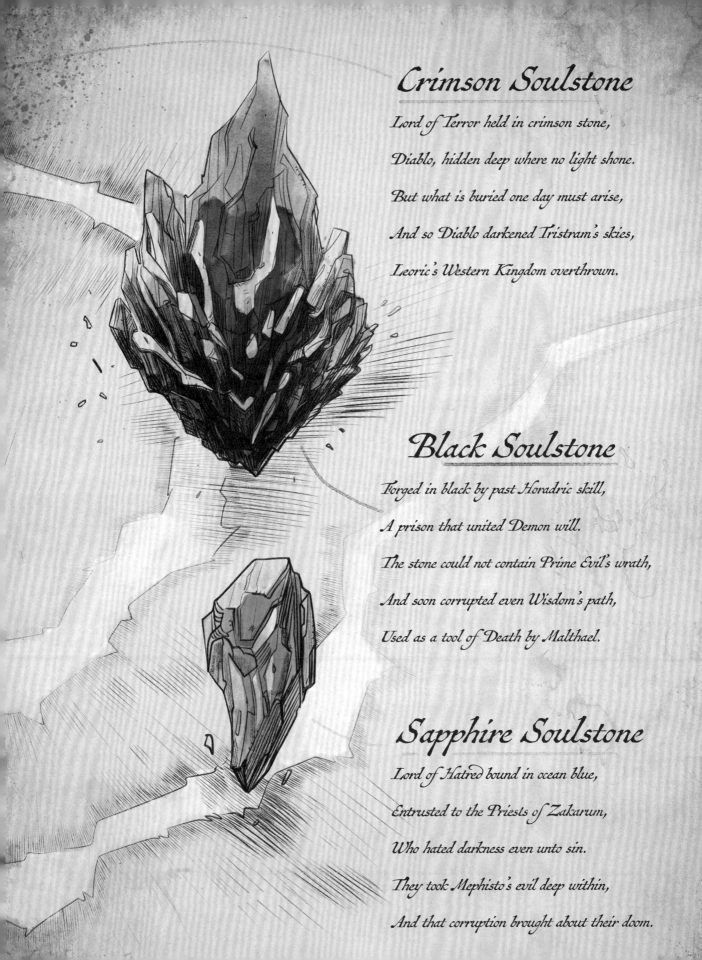

Crimson Soulstone

Lord of Terror held in crimson stone,

Diablo, hidden deep where no light shone.

But what is buried one day must arise,

And so Diablo darkened Tristram's skies,

Leoric's Western Kingdom overthrown.

Black Soulstone

Forged in black by past Horadric skill,

A prison that united Demon will.

The stone could not contain Prime Evil's wrath,

And soon corrupted even Wisdom's path,

Used as a tool of Death by Malthael.

Sapphire Soulstone

Lord of Hatred bound in ocean blue,

Entrusted to the Priests of Zakarum,

Who hated darkness even unto sin.

They took Mephisto's evil deep within,

And that corruption brought about their doom.

WORLDSTONE

A few more words are needed on the subject of the Worldstone, even though I doubt its nature will ever be fully understood. It has been called the Eye of Anu, and it embodied the endless cycles of birth and death, destruction and creation. Desire to control its infinite power fueled the Eternal Conflict until Inarius and Lilith stole it and brought it to Sanctuary, where the stone eventually became corrupted.

That is why Tyrael used his sword, El'druin, to shatter it.

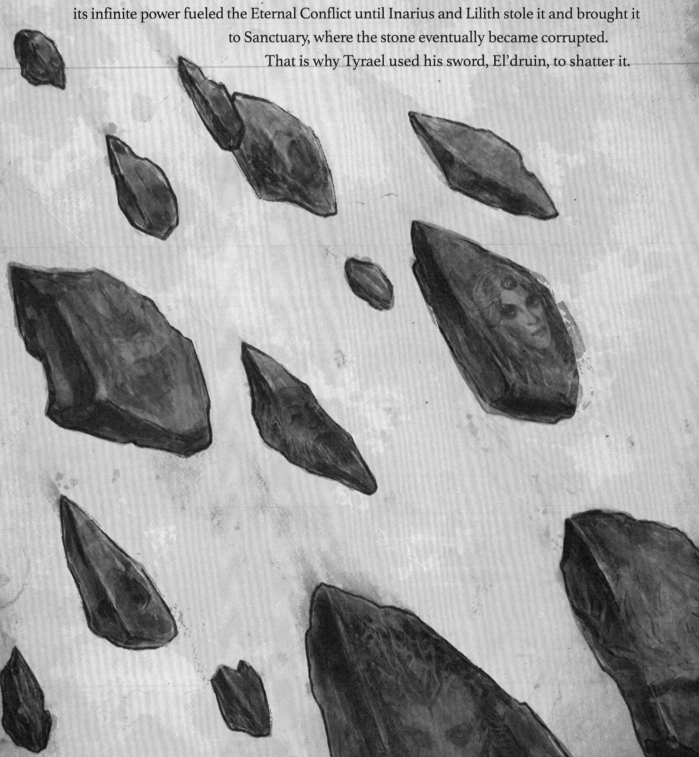

SHARDS & SPLINTERS

The Worldstone was nearly as large as the mountain that housed it, Mount Arreat, and the cataclysm that followed its destruction left that high peak a crater. The blast also scattered dangerous shards of the Worldstone across Sanctuary.

Some of those shards fell to earth imbued with the power of death, and death followed them. The corruption of the Worldstone tainted even those small fragments, and there were some who attempted to use the shards for evil purposes. A witch named Eskara attempted to summon a powerful demon named Skarn. The Necromancer Lethes sought to wield the power of a shard for herself to gain mastery over life and death. The power of another shard even helped revive an ancient evil known as the Countess, who once bathed in the blood of the innocent and had been defeated before. Brave heroes retrieved these three shards and brought them to Deckard Cain. Even he was unable to destroy them, despite his vast knowledge, without the aid of an angelic dagger.

It is possible there are many of these shards left in Sanctuary, and that is what troubles me. Splinters of the Worldstone might appear in a farmer's field as the earth is tilled, or in a riverbed beneath a swimming child, or in the garden of a cruel lord. Wherever a shard is found, suffering will surely follow. I think it will be the task of any future Horadrim to follow rumors of these shards and splinters and collect them. If these fragments cannot be destroyed, they must at least be contained and hidden by those who understand the true dangers they pose.

I have read that his attempt unleashed demons in his home in Westmarch.

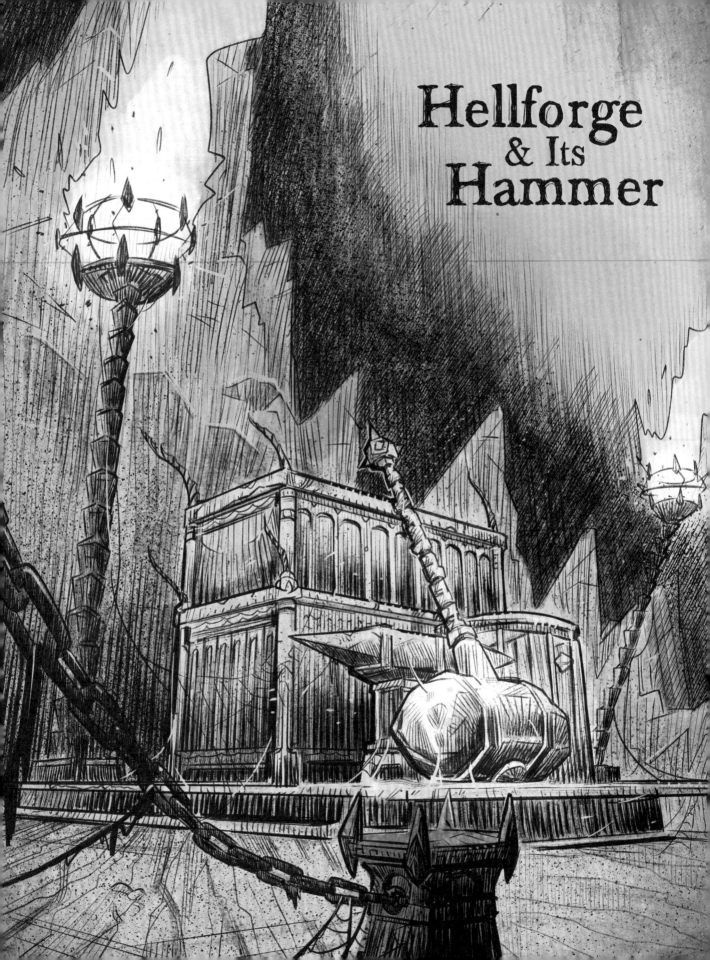

Hellforge
& Its
Hammer

The greatest weapons wielded by the legions of the Burning Hells are made in the realm of Baal, Lord of Destruction, where the fires of the Hellforge burn. Very few mortals have ever seen that place or felt its searing heat against their skin. Those who did venture into that inferno went to destroy the Blue and Crimson Soulstones, and thereby banish the spirits of Mephisto and Diablo to the Black Abyss.

To succeed in this, they had to defeat a demon called Hephasto the Armorer, a towering monstrosity with wide horns and powerful arms strengthened by thousands and thousands of strikes with his Hellforge Hammer against the Anvil of Fury. He fed his furnaces a diet of suffering, and it is said that his diabolical skill produced weapons that could <u>only</u> be used in acts of destruction and desecration.

That is why I urge you to forsake any thought you may have to use a weapon of Hell, should you ever find one. Perhaps you believe you could put it to use for good, and perhaps you could. For a time. Ultimately, I do not believe such a plan can ever lead to anything but ruination, no matter how righteous the motives behind it. A demonic weapon was made for one purpose, and before a mortal could ever hope to bend its will, the weapon will twist the will of the wielder.

MALTHAEL'S CHALICE

According to most texts, Malthael was the oldest member of the Angiris Council of Archangels and was once entrusted as its leader. Within the borders of his domain in the High Heavens lay the Pools of Wisdom. Their waters flow with the sum of all emotion and passion in creation, and it is from those wells that Malthael filled Chalad'ar, his Chalice of Wisdom. I have often wondered what happened to his mind in the countless hours he spent gazing into its basin. What did he see that convinced him to forsake his Aspect of Wisdom for the Aspect of Death? What caused him to embrace destruction as his purpose?

I do not wish to believe that any true wisdom led him down the path he chose. Nor do I need to look into a bowl of water to scry my own mortality. I know that death is inevitable, but that knowledge leads me to merely accept death, not to embrace it. Death may be the end, but it is not the answer. Or as it is written in The Gospel of Death, our mortality isn't earned—it simply is.

I have never looked into Malthael's Chalice. If it is like other vessels, the water's surface will function as a mirror as well as a window. As the ravages of the Eternal Conflict took their toll on Malthael's mind, as they must have, it is natural that his pain and doubt would be reflected back at him when he stared into Chalad'ar. I believe he poisoned the source of his wisdom with his own despair.

Beware the fortune teller who knows your fears. Avoid chalices. Live as if you will die.

OF WISDOM & SCYTHES

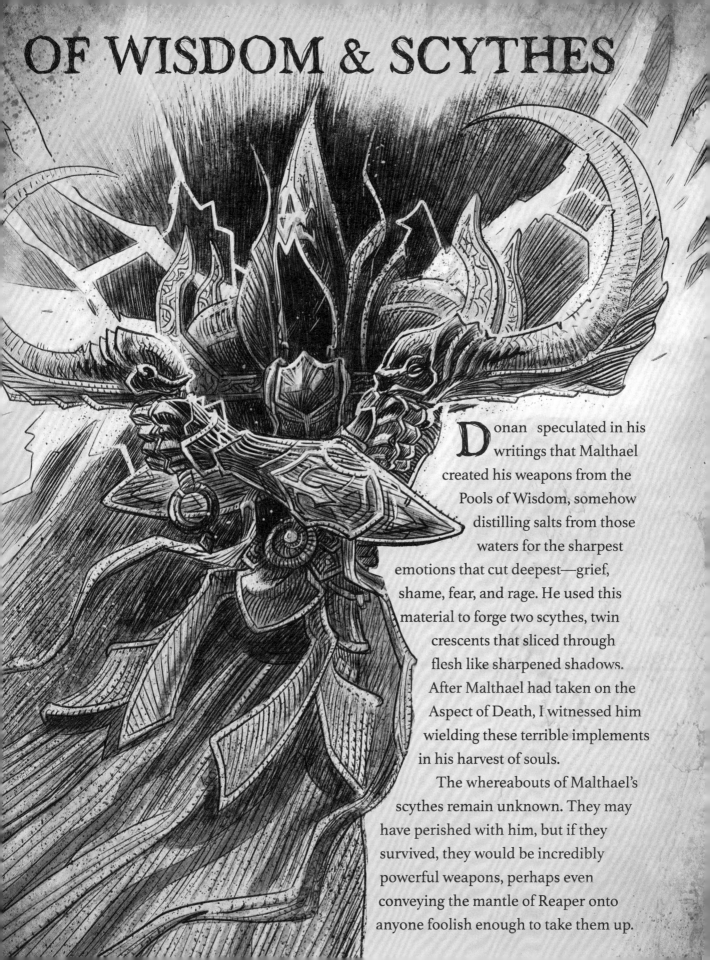

Donan speculated in his writings that Malthael created his weapons from the Pools of Wisdom, somehow distilling salts from those waters for the sharpest emotions that cut deepest—grief, shame, fear, and rage. He used this material to forge two scythes, twin crescents that sliced through flesh like sharpened shadows. After Malthael had taken on the Aspect of Death, I witnessed him wielding these terrible implements in his harvest of souls.

The whereabouts of Malthael's scythes remain unknown. They may have perished with him, but if they survived, they would be incredibly powerful weapons, perhaps even conveying the mantle of Reaper onto anyone foolish enough to take them up.

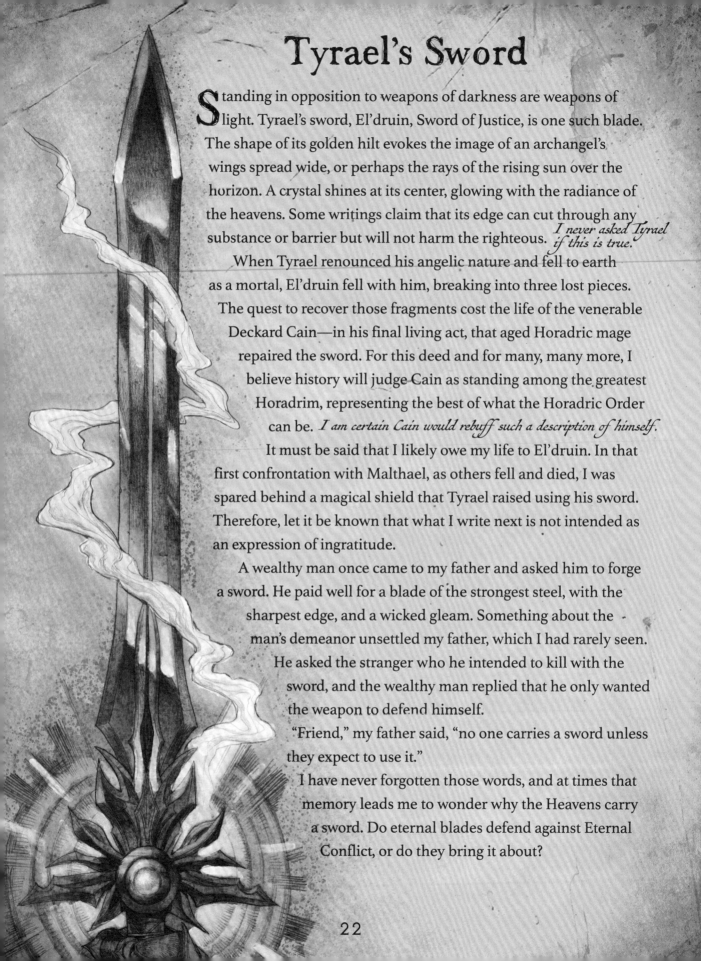

Tyrael's Sword

Standing in opposition to weapons of darkness are weapons of light. Tyrael's sword, El'druin, Sword of Justice, is one such blade. The shape of its golden hilt evokes the image of an archangel's wings spread wide, or perhaps the rays of the rising sun over the horizon. A crystal shines at its center, glowing with the radiance of the heavens. Some writings claim that its edge can cut through any substance or barrier but will not harm the righteous. *I never asked Tyrael if this is true.*

When Tyrael renounced his angelic nature and fell to earth as a mortal, El'druin fell with him, breaking into three lost pieces. The quest to recover those fragments cost the life of the venerable Deckard Cain—in his final living act, that aged Horadric mage repaired the sword. For this deed and for many, many more, I believe history will judge Cain as standing among the greatest Horadrim, representing the best of what the Horadric Order can be. *I am certain Cain would rebuff such a description of himself.*

It must be said that I likely owe my life to El'druin. In that first confrontation with Malthael, as others fell and died, I was spared behind a magical shield that Tyrael raised using his sword. Therefore, let it be known that what I write next is not intended as an expression of ingratitude.

A wealthy man once came to my father and asked him to forge a sword. He paid well for a blade of the strongest steel, with the sharpest edge, and a wicked gleam. Something about the man's demeanor unsettled my father, which I had rarely seen. He asked the stranger who he intended to kill with the sword, and the wealthy man replied that he only wanted the weapon to defend himself.

"Friend," my father said, "no one carries a sword unless they expect to use it."

I have never forgotten those words, and at times that memory leads me to wonder why the Heavens carry a sword. Do eternal blades defend against Eternal Conflict, or do they bring it about?

Yl'nira

Yl'nira, the Edge of Temperance, was a dagger, and according to one account, it originally belonged to an archangel who followed Inarius to Sanctuary. It was later given to that angel's Nephalem child and eventually came to be hidden in the Temple of Namari, on a jungle island south of Aranoch known as the Bilefen. It was an elegant blade, decorated with delicate inlay and filigree. In the midst of its ornamentation stood a golden hooded figure, peaceful and mysterious, bearing a glittering jewel of pale blue in its arms.

A dagger and a sword are very different things. A sword has but one purpose, whereas a dagger is much more than a weapon. It is a <u>tool</u>.

Yl'nira wasn't known for the demons it slew, nor for the glorious battles it won. It was put to different uses. Its light was carried into Hell to destroy the ghastly Pits of Anguish in which demons spawned. Deckard Cain wielded its power to shatter the dangerous Shards of the Worldstone. As a weapon, some might say that Yl'nira accomplished little. As a tool, that dagger may have saved Sanctuary. Let it therefore serve as a reminder that there are many ways to defeat evil. Do not be too quick in dismissing the humblest of tools or the smallest of allies, even the ones that seem the least deadly. Seek only to be useful.

Itherael's Scroll

Talus'ar. The Scroll of Fate.

This relic is used by the archangel Itherael, the keeper of lore in the High Heavens. His domain contains the Library of Fate, and the tomes housed therein contain histories upon histories, and knowledge within knowledge. The Scroll of Fate is reportedly a manifestation of the whole library, the sum of Heaven's vast intelligence. And yet, it failed to mention the Nephalem, a startling omission of fateful significance.

It seems that even the Scroll of Fate could only reveal what the angels already knew and understood. They did not anticipate the Nephalem, so neither did the scroll. I do not doubt the extraordinary power of Talus'ar. But it is not infallible.

In writing this book, I have thus far referred to the writings of Cain and Donan and other texts as sources. Perhaps that gives my words added weight or makes them seem more trustworthy. However, what if Cain and Donan were wrong in what they wrote? Worse yet, what if they intended to deceive? We would be wise to remember that the map is not the territory. Books and scrolls are not the same as knowledge.

Including this book!

GATES OF HELL

While a gateway is often built to protect against invaders, there are few mortals to whom the Gates of Hell would be closed. The evil that lies beyond will welcome almost any soul who voluntarily enters. If that soul is still clothed in a physical form, the flesh of that body will be stripped and rendered to adorn the walls, which are strung with the dismantled remains of innumerable victims. Cracks and fissures in the uneven ground around the gates exhale a poisonous miasma, the rank effluvia of unspeakable filth and degradations. The deafening wails, screams, and roars that stab the ears can cause madness in the same moment they are first heard. The ramparts seem to rise to the height of mountains, built of stones on which are carved repulsive and forbidden runes, as though each rock received its own curse as it was laid. The gates of iron were built to withstand the onslaught of angels and to cause the heavens to quake. They stand with cruel defiance that would gladly see the entire world destroyed before suffering defeat.

But they are not the only gates to the only hell. Many of us walk through more subtle portals into our own personal hells, often without realizing it until it is too late. Once there, we do not need demons to torture us, for we do that to ourselves with implements such as shame and self-hatred. None can free us, and those who love us can often only stand by and watch as we suffer, as though we have dragged them with us into the hells of our making.

I would like to believe that if all the gates to all the hells were as terrible and obvious as the Gates of the Burning Hells, no one would walk through them. Yet I know there will always be souls so lost they feel unworthy of any other place.

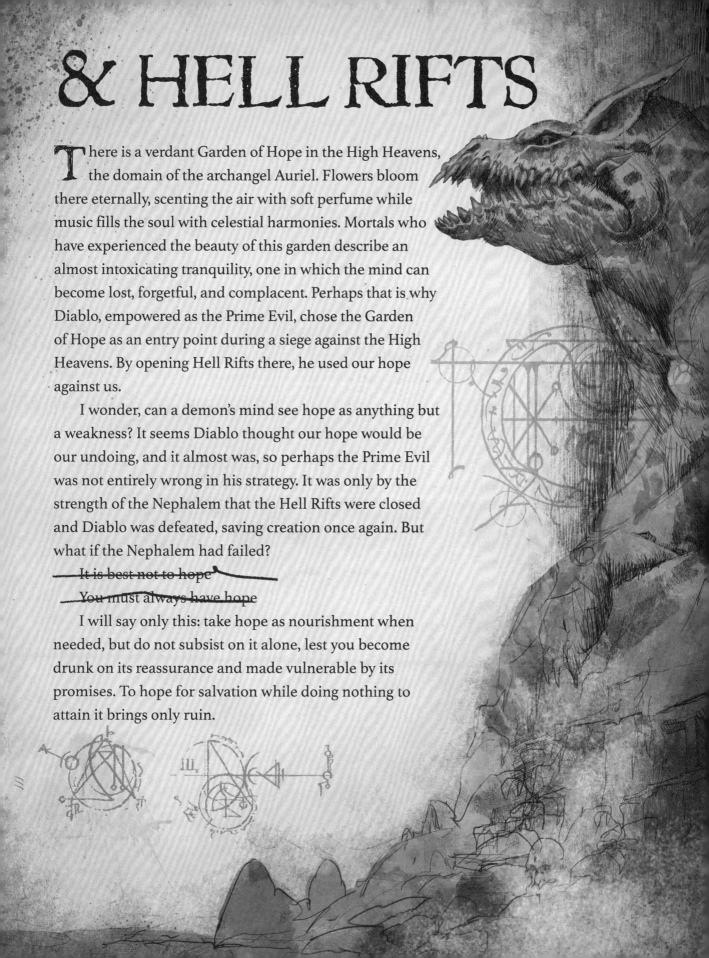

& HELL RIFTS

There is a verdant Garden of Hope in the High Heavens, the domain of the archangel Auriel. Flowers bloom there eternally, scenting the air with soft perfume while music fills the soul with celestial harmonies. Mortals who have experienced the beauty of this garden describe an almost intoxicating tranquility, one in which the mind can become lost, forgetful, and complacent. Perhaps that is why Diablo, empowered as the Prime Evil, chose the Garden of Hope as an entry point during a siege against the High Heavens. By opening Hell Rifts there, he used our hope against us.

I wonder, can a demon's mind see hope as anything but a weakness? It seems Diablo thought our hope would be our undoing, and it almost was, so perhaps the Prime Evil was not entirely wrong in his strategy. It was only by the strength of the Nephalem that the Hell Rifts were closed and Diablo was defeated, saving creation once again. But what if the Nephalem had failed?

~~It is best not to hope~~

~~You must always have hope~~

I will say only this: take hope as nourishment when needed, but do not subsist on it alone, lest you become drunk on its reassurance and made vulnerable by its promises. To hope for salvation while doing nothing to attain it brings only ruin.

Demonic Relics

The rebellion in Hell that saw the Prime Evils exiled to the mortal plane also left them incorporeal. For any of the three to take physical form now requires a body for their spirit to possess. Over time, the presence of the demonic entity will corrupt the victim's human flesh, twisting it into a grotesque simulacrum of the Prime Evil's physical form. When this abomination is defeated or destroyed, the entity is banished once again from the material world, leaving behind whatever remains of its dead and mangled shell. Just as some venerate and utilize the teeth or finger or femur of a sanctified corpse, so others make use of the profane leavings of demons.

When I consider these relics and their uses, I cannot help wondering if anything of the human hosts does remain, hidden deep within them. When the Horadrim exploited the magical properties of an object like the horn of Diablo, did its power come from the demon's essence? Or did it arise from a lingering residue of the host's righteousness, however faint? Or is it perhaps the combination that matters, the synthesis of natures that once granted the Firstborn their tremendous power?

Brain of Mephisto

The Lord of Hatred left this gelatinous relic behind. Many think hatred sits in the heart, but it begins in the mind, with thoughts and stories whispered into our ears, like worms that wriggle and gnaw their way inward and leave us infested. Mephisto's Brain reminds us that all are vulnerable to the corrupting influence of hatred, even those who believe they are engaged in righteous work.

Eye of Baal

The Eye of Baal was a ghastly reminder of what the Lord of Destruction saw when he looked at our human world—and what he wanted to do to it. I was not at the Barbarian city of Sescheron when Baal laid siege with his armies, though I have read accounts by the few survivors of that assault. They describe the Prime Evil atop his litter, surveying the city with ravenous malice and an insatiable lust for destruction. His vision for Sanctuary was of a wasteland stained with blood.

Horn of Diablo

Diablo's horns are sharp enough to pierce and gore, though anyone so injured would be wise to pray the wound is swiftly fatal. If not, the tainted gash will fester and rot from the inside out, giving the body of the injured over to maggots and hellish parasites long before death ends the feverish agony. Diablo's whole body bristles with vicious, bony spikes. Even a relic of one of his lesser horns would be enough to cause terror.

Cursed Pillar

I have put off talking about this subject long enough, and I should know better. I have enough experience with pain to have learned that suffering is made worse by attempts to avoid it. In this moment, it is the memory of Donan's death that I resist.

In our quest to stop Lilith, we traveled through a gateway in the ancient city of Caldeum, into the Burning Hells. The darkness there can be as difficult to describe as the blinding light of the High Heavens. The mind can scarcely comprehend the gruesome blasphemies encountered, and I hope no other mortal will ever be called to venture there again. But if that should be your path, I urge you to remember that the very walls are alive with malice.

We had taken shelter in a small cavern. The dank air in that chamber clung to us with the smells of a charnel house and a fetid swamp. Ranks of tall columns surrounded us. At one point, Donan heard wet, squelching movement in the shadows, and he recklessly, foolishly went to investigate alone. He discovered that the pillars standing over us had been sculpted from demonic tissues and animated by foul magic. They uncoiled tendrils lined with teeth and jagged barbs. One of these feral claws ripped into Donan's belly, a mortal wound, but he lived long enough to warn us of the danger. Had he not found the strength to endure until then, we might have perished with him. All would have been lost. As it was, the fight cost us dearly.

I wish now I had paid more attention to what Donan was doing. I wish I had urged him to be more cautious. Such thoughts are the self-torture of memory, and I suspect he would have ignored me. I have come to believe that Donan's grief at being preceded to the grave by his wife and son may have led some part of him to seek his own death.

Against the cruel
and lashing wind,
against the howling
winter hounds,
the Druid college
towers stand
upon the hard and
bitter ground.

A stanza from a Scosglen folksong. This land is haunted in a way I have not felt in other regions of Sanctuary. In the middle of the night, unearthly wailing can be heard off in the cold mists that shroud the moors. Werewolves stalk the gloom beneath the dense forests. Khazra goatmen gather to waylay travelers and raid unprotected settlements. Amidst these threats, the Druid colleges hold fast, bulwarks against the encroaching wilds. At Túr Dúlra, the greatest of the colleges, there is an ancient oak tree named Glór-an-Fháidha. The Druid reverence of this tree speaks to their deep connection with the other-than-human world. Were it not for the influence of Hell, perhaps those who call Scosglen home could live in greater harmony with the other beings who share this land.

Painting of Donan, Airidah, & Nafain

There is a painting hanging near me in Donan's study. It depicts him with two Druids, Airidah and Nafain. It was undoubtedly commissioned to recognize the trio's heroism in defending Scosglen against the demon Astaroth, whose essence they imprisoned in a Soulstone. Donan was a humble man, but I imagine the painting gave him joy, and possibly even pride.

All three of the painting's subjects are now dead and gone. Tragically, only Donan met his end with his honor and soul intact. Airidah and Nafain both succumbed to temptations that unraveled their legacies and undid the very achievements commemorated by the painting. Now the image only serves to remind the viewer of who Airidah and Nafain once were and what became of them at the end. In that way, it is a cautionary relic that feels almost haunted, or cursed.

Do not assume that because you have achieved greatness or performed good deeds in the past that you are immune to evil's seduction. Do not believe the lie that you are above sin. Even the most righteous may fall, given the right push in the wrong direction.

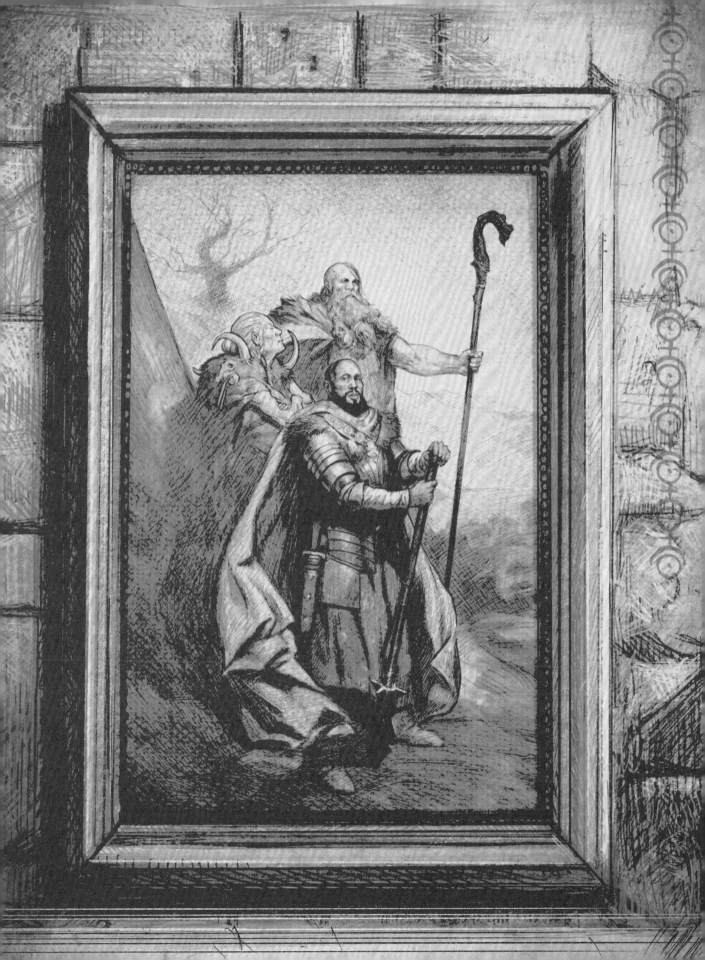

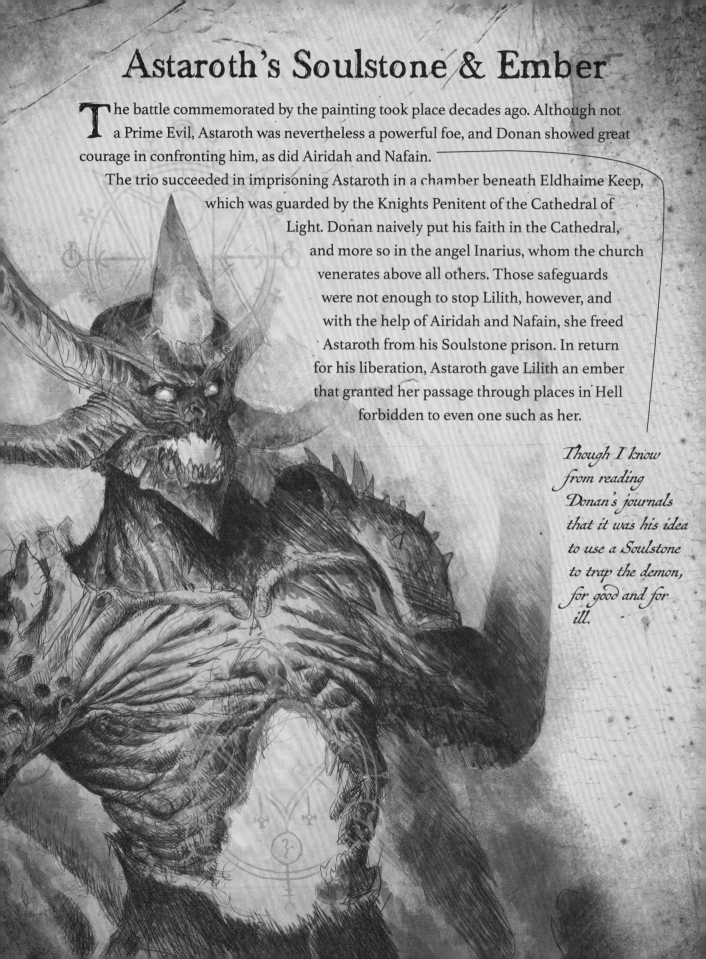

Astaroth's Soulstone & Ember

The battle commemorated by the painting took place decades ago. Although not a Prime Evil, Astaroth was nevertheless a powerful foe, and Donan showed great courage in confronting him, as did Airidah and Nafain.

The trio succeeded in imprisoning Astaroth in a chamber beneath Eldhaime Keep, which was guarded by the Knights Penitent of the Cathedral of Light. Donan naively put his faith in the Cathedral, and more so in the angel Inarius, whom the church venerates above all others. Those safeguards were not enough to stop Lilith, however, and with the help of Airidah and Nafain, she freed Astaroth from his Soulstone prison. In return for his liberation, Astaroth gave Lilith an ember that granted her passage through places in Hell forbidden to even one such as her.

Though I know from reading Donan's journals that it was his idea to use a Soulstone to trap the demon, for good and for ill.

Druidic Talisman

The Scéal Fada is the holy text of the Druids. It tells the long story of their history, which reaches back to the Firstborn in Sanctuary. According to legend, the Druids were once part of the northern tribes at Mount Arreat. They left behind the martial ways of that Barbarian life when a man named Vasily led a small group of warrior-poets into the forests to seek unity with the land. There they practiced a creed of harmony with the natural world, and through their devoted study developed a powerful kinship with the living beings around them. In time, they even learned to communicate with the animals and plants.

This relationship is symbolized by the talismans that Druids carry and wear. Some of these emblems will look like little more than morbid scraps and trinkets to outsiders. Skulls and bones, teeth and claws, feathers and furs all speak to the communion between the Druid and the living world. In Scosglen, they place their faith in the ground beneath their feet more than they will ever trust the High Heavens. The Druids have little use for angels, which is why they take a dim view of the Cathedral of Light and its proselytizing efforts within their borders.

For some time, the Druids tolerated the presence of the church, but with the Knights Penitent marching across the moors, some are restless to see the Cathedral gone. For its part, the church views the Druids as primitive and superstitious. They see no Light in the deep forests, the highlands, the colleges, or in the talismans the Druids wear.

Conflict was and is inevitable.

In Scosglen, they talk of the leader Fhaela-Géar. This is confirmed to be Vasily.

Airidah's Talharpa

The beauty of Scosglen is stunning and stark. Above its deep woodlands, bare fells rise with an ancient grandeur, as if they were once monumental statues of the titans that stride Pandemonium. Countless years of wind and rain and ice have worn them down to crouching, bald mounds. Wiry grass and heath grow in their folds, and heavy mists fill their glens. Many who wander in those highlands are never seen again, and those who return speak of voices calling to them, luring them into the fog. Some are no doubt led over the edge of some precipice and dashed on the rocks below. Others are taken by wraiths and vengeful spirits. Still others are rumored to be swallowed by the earth itself.

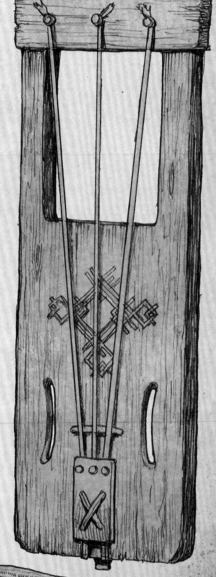

The folk here say that the Druid Airidah could summon this haunted mist with her talharpa, a bowed lyre with strings of twisted horsehair. The instrument's mournful melodies carried over the hills and down into the valleys, akin to a fiddle, but more primitive, singing of loneliness and loss. The mist its music accompanied seemed to reflect the state of Airidah's mind. A dense fog of fear and doubt made her vulnerable to Lilith's false promises, a failing that cost her life and many others. Airidah wanted to strengthen her people, except she was blind to her own weakness.

Years from now, when I think back on my time in Scosglen, I will hear the eerie cry of Airidah's Talharpa in my memories. The instrument survived her death, yet I do not know its present whereabouts.

Weeping Cairns

The entrance to this ancient Druid burial complex can be found above the village of Braestaig in the Scosglen Hills. Its stone doors are sealed by powerful runes, and only by chanting the proper incantations will they open. Doing so may draw forth the unquiet dead whose spirits linger in the tombs, so any trespassing there should be undertaken only out of the greatest necessity. The Druids buried in that place were heroes of legend, worthy of honor in death. They can be roused to anger if their resting place is defiled, as it was by Airidah and Lilith. The bodies of intruders who ignore these cautions may be added to the collection of desiccated corpses that fill the chambers and corridors of the Weeping Cairns. Do not blame the dead for this. Blame the living who have lost respect for the dead.

Cairn Wardstones

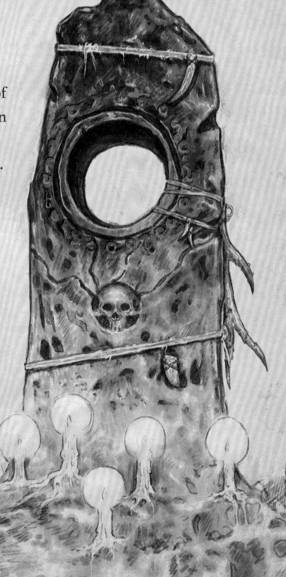

These ancient monoliths rise like the very bones of Scosglen, carved from its gray rock. They stand in silent vigil within the Weeping Cairns, empowered as sentries by runes chiseled across their impassive faces. The builders of those tombs placed the wardstones to guard the resting spirits of the dead, although Lilith and Airidah corrupted even these protections so that they barred passage through the tombs and incited the ghosts to vengeance.

That is the power of evil. The demons of the Burning Hells would see every noble deed, every righteous act, all goodness in Sanctuary twisted to their vile purposes. Nothing is sacred enough to be safe. Nothing is so pure that it stands beyond their ability to desecrate it.

TORMENTED

Airidah dwelt atop a fog-shrouded crag called Solitude, and she guarded her domain with the Tormented Remains of the dead. The grimacing, tortured corpses of revered Druids had been wrenched upward through the ground, stretched and bound by demonic roots, surrounded by monstrous Wildwoods in a perversion of Druid nature magic. As with the haunted mist that Airidah could summon with her talharpa, I believe these blasphemies portrayed the inner state of her mind and soul. Her battle with Astaroth must have left her shaken to her core, for she lived in torment, always fearing the return of Hell to Scosglen.

REMAINS

In times of fear, the weak often turn to whichever tyranny promises to take that fear away, and so it was with Airidah. She accepted the dreadful rule of Lilith in exchange for a false promise of protection. In the end, it was only Airidah's death that freed her from her torment.

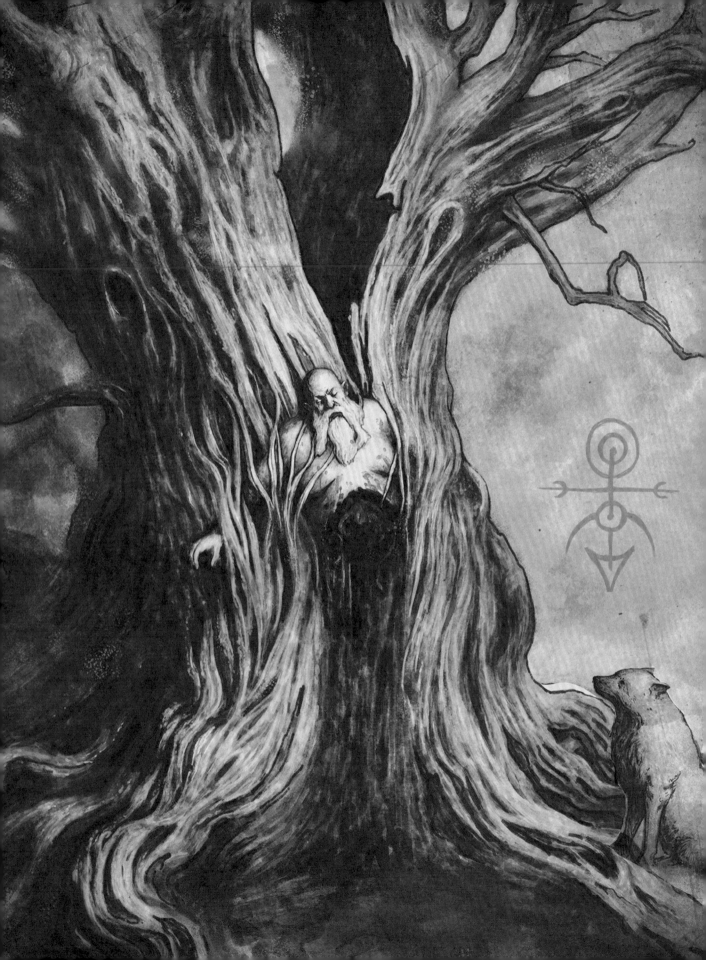

Nafain's Tree & Spear

Like Airidah, the Druid Nafain succumbed to Lilith's manipulations. To rid his lands of the Cathedral of Light, he accepted the help of shadow and darkness. But Lilith used his hatred and anger for her own ends, and like Airidah, Nafain gave Lilith what she needed to free the demon Astaroth from his Soulstone. In reward for his service, Lilith impaled Nafain on a tree. But this violence did not kill him. Her ritual left him alive in agony as he watched his own blood pour out of him to nourish a gestating beast. Nafain finally begged for death to end his suffering, and he found it at the point of his own spear. I believe the tree from which he hung remains standing. If so, it may be scarred forever by Lilith's magic, marked as a demon-tree, and best avoided. Living things that taste human blood often crave it ever after.

The shaft of this weapon is made from gnarled and ancient bog oak that was hardened and blackened by many centuries spent buried in peat beneath the moors. Runes carved along its length add to its strength and grant it other magical properties expressly for Druidic purposes. Charms of ivory and fragments of carved bone hang from leather cords wrapped around the wood. A ring of wolf teeth surrounds the base of the spear's curved blade, which was forged from strong steel, embossed with a wolf's head, and further imbued with runes.

What I cannot say is whether this weapon will carry the blessing of Nafain as he was or the curse of Nafain as he became. This may be the weapon of a legendary hero or the spear of a traitor. Perhaps it needs a new warrior to wield it, one who will rewrite its legacy.

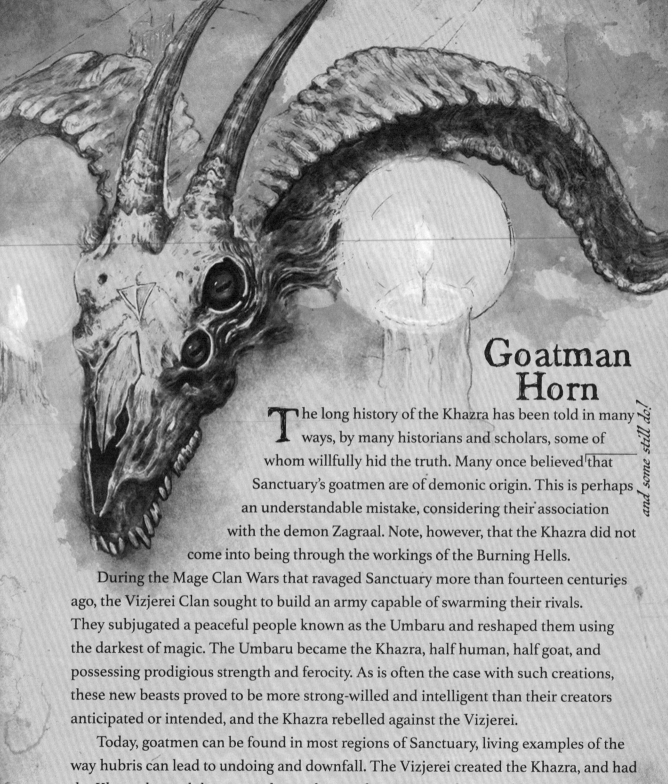

Goatman Horn

The long history of the Khazra has been told in many ways, by many historians and scholars, some of whom willfully hid the truth. Many once believed that Sanctuary's goatmen are of demonic origin. This is perhaps an understandable mistake, considering their association with the demon Zagraal. Note, however, that the Khazra did not come into being through the workings of the Burning Hells.

During the Mage Clan Wars that ravaged Sanctuary more than fourteen centuries ago, the Vizjerei Clan sought to build an army capable of swarming their rivals. They subjugated a peaceful people known as the Umbaru and reshaped them using the darkest of magic. The Umbaru became the Khazra, half human, half goat, and possessing prodigious strength and ferocity. As is often the case with such creations, these new beasts proved to be more strong-willed and intelligent than their creators anticipated or intended, and the Khazra rebelled against the Vizjerei.

Today, goatmen can be found in most regions of Sanctuary, living examples of the way hubris can lead to undoing and downfall. The Vizjerei created the Khazra, and had the Khazra hunted that mage clan to the very last sorcerer, they would still have only reaped what they, themselves, had sown. Let that be a lesson to those who would use dark magic. *Even in the service of good.*

and some still do!

Yorin's Mace

Yorin was Donan's son. I did not know him well, but he seemed a capable lad who showed great courage. Without hesitation, he risked his life defending the villages of Scosglen, including Braestaig, and willingly entered the Weeping Cairns on Airidah's trail. As alluded to in Donan's personal journals, Yorin strained against his father's efforts to keep him safe, believing himself a man, ready for more responsibility and challenges. Indeed, Yorin was more prepared than most to confront demonic forces. It wasn't enough.

Though Donan tried to send his son away from the battle with Lilith at Eldhaime Keep, she slew the Knights Penitent who were with Yorin and took the boy captive. The finding of Yorin's Mace granted Donan a brief, cruel hope for his son's survival, but this proved futile. Lilith had chosen Yorin as the host for Astaroth's essence and drove the Soulstone into the boy's body. Donan believed his son strong enough to resist the influence of the demon's spirit, and I think it is possible that the youth held out longer than many others could have. No one can resist the evil of a demon forever. By the time Donan caught up with his son at Cerrigar, the corruption was complete. Though Astaroth was defeated once again, the boy could not be saved.

Yorin's Mace was a gift from Donan to his son, and it is not of Druid make. Donan wrote in his journals that he acquired it from a merchant, who claimed it had come from the desert tombs outside Lut Gholein. Nothing about the mace leads me to doubt this story. In shape, it is a war hammer, forged from a mysterious alloy. The weapon appears quite ancient, and it possesses a lethal grace that allowed even a warrior as young as Yorin to wield it. Unlike a weapon such as Nafain's spear, I do not believe there is any chance of it being cursed, for Yorin kept his honor until the end.

For your sake, Neyrelle, I have to believe that such evil can be resisted.

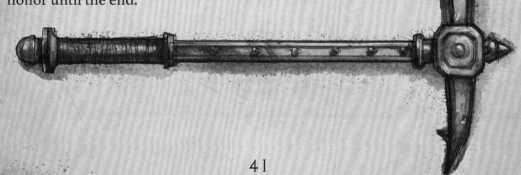

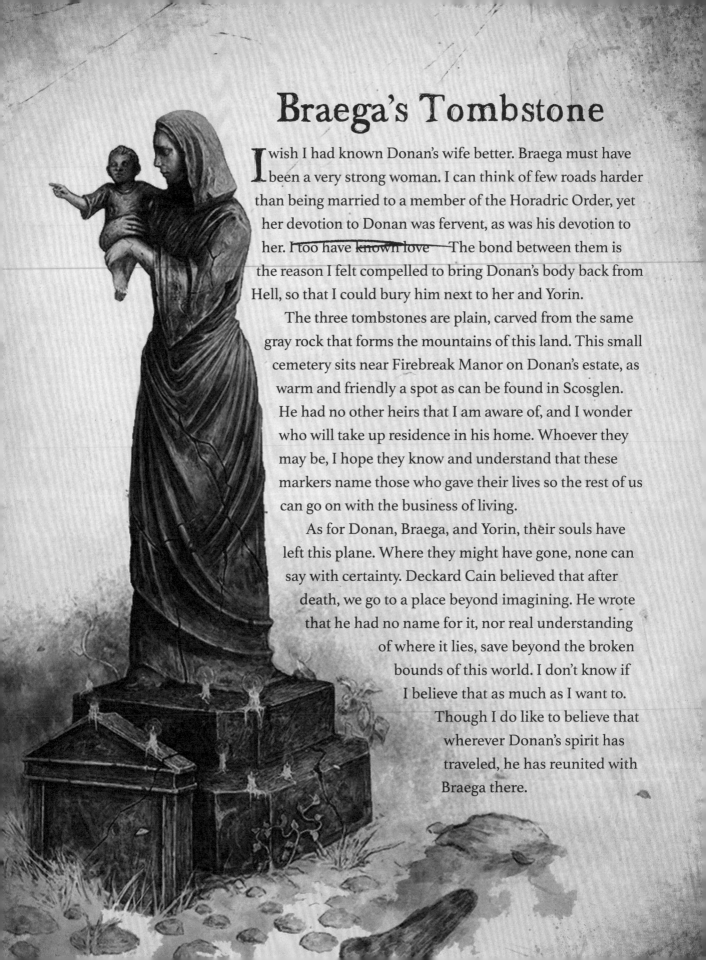

Braega's Tombstone

I wish I had known Donan's wife better. Braega must have been a very strong woman. I can think of few roads harder than being married to a member of the Horadric Order, yet her devotion to Donan was fervent, as was his devotion to her. I too have known love— The bond between them is the reason I felt compelled to bring Donan's body back from Hell, so that I could bury him next to her and Yorin.

The three tombstones are plain, carved from the same gray rock that forms the mountains of this land. This small cemetery sits near Firebreak Manor on Donan's estate, as warm and friendly a spot as can be found in Scosglen. He had no other heirs that I am aware of, and I wonder who will take up residence in his home. Whoever they may be, I hope they know and understand that these markers name those who gave their lives so the rest of us can go on with the business of living.

As for Donan, Braega, and Yorin, their souls have left this plane. Where they might have gone, none can say with certainty. Deckard Cain believed that after death, we go to a place beyond imagining. He wrote that he had no name for it, nor real understanding of where it lies, save beyond the broken bounds of this world. I don't know if I believe that as much as I want to. Though I do like to believe that wherever Donan's spirit has traveled, he has reunited with Braega there.

Prava's Decree

The Reverend Mother Prava leads the Cathedral of Light. Even now, after the devastating failure of her Knights Penitent to stop Lilith, and after the death of Inarius, she continues to preach with the same fervor. Unless she truly is a mindless fanatic, I can only conclude that something other than faith compels her.

Her zeal and jealousy have led her to issue a decree in which she has the hypocritical audacity to blame the Horadrim for Lilith's resurgence. Consequently, we are to be eradicated. This might prove inconvenient if the Horadrim still existed in a substantive way, but it is no more than a minor irritation. The Cathedral has not yet attained the kind of power it would take to carry out such a decree, and the Horadrim still have many friends. That said, to completely ignore Prava and the Cathedral would be foolhardy. She is a formidable adversary who may yet find ways to cause damage and suffering.

The most obvious motivations would be pride, gold, and power.

The Horadrim have used their dark magics to bear a great evil into our world.

Commit their wicked souls to the Father and retrieve the Soulstone.

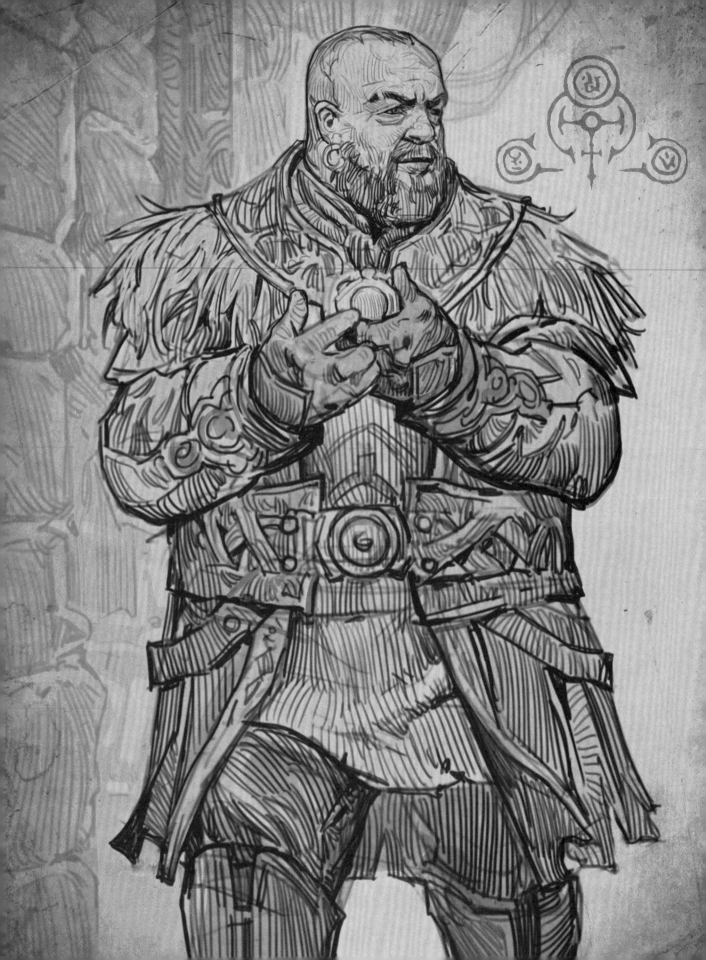

Donan's Fur Cloak & Clasp

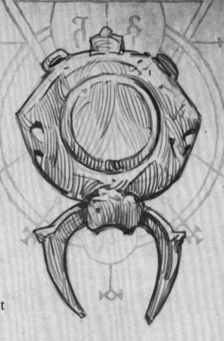

Though Donan was not a Druid, he did live among them and wore furs after their kind. His cloak of wolf pelts recalls their nature magic of shapeshifting, and it is well suited to the climate of Scosglen. It keeps out the biting wind and rain, and it warms against the cold mist. The fur has been rubbed away in places from heavy use. It carries at least one burn mark, where I imagine Donan sat too close to the fire on some frosty night. There are many bloodstains, some brown and old, some new. They speak loudly of Donan's valiance, and I will not silence them by trying to clean them.

To the south, in the cities of Kehjistan, Horadrim of the past wore fine embroidered robes that smelled of rare and costly incense. Donan's cloak smells of musk, leaves, and woodsmoke, and the crude stitching has been repaired many times over. It is a humble garment, and yet I believe Donan felt pride when he wore it.

A bronze clasp holds the cloak in place about my shoulders, which Donan must have had made custom by a local blacksmith. It combines the Horadric symbol with a Druidic wolf's head, and the workmanship is quite fine.

I will wear both as I go forth on my journey, as personal talismans. The cloak will defend me well against the elements as I travel south from Scosglen into the

Fractured Peaks. More importantly, it will help me remember all that Donan gave. Even before his death, he had lost everything: his wife, his son, and finally his faith as he witnessed the failure of Inarius and the Cathedral. His sacrifices must not have been in vain.

It is time for me to begin my journey. Before I depart, there is another relic I must acquire.

Leaf from Glór-an-Fháidha
ᚠᛖᚱᛏᛁ

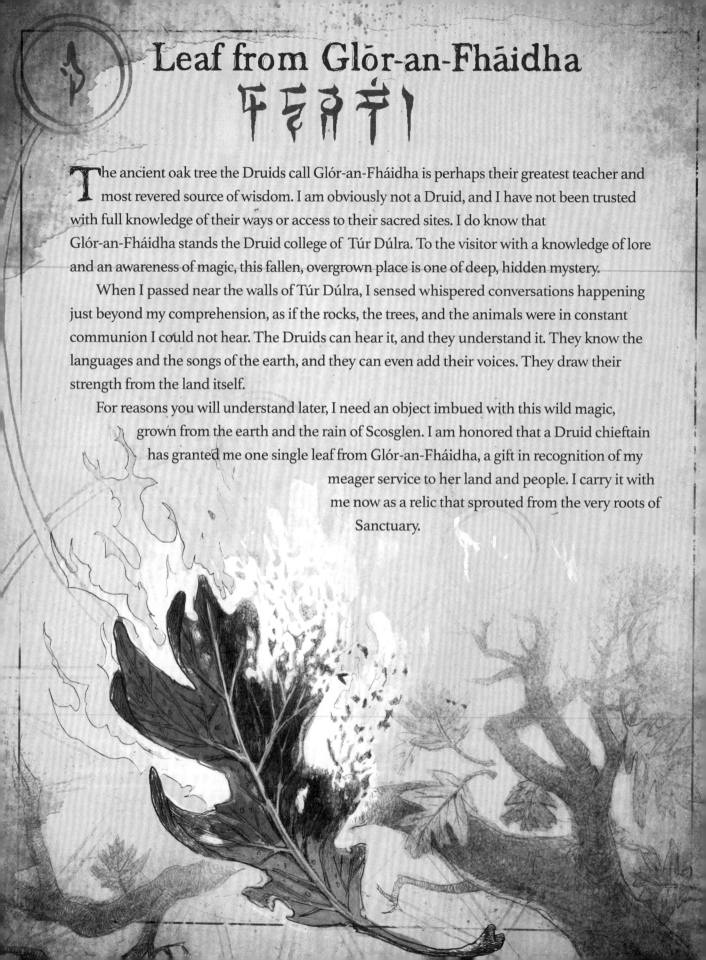

The ancient oak tree the Druids call Glór-an-Fháidha is perhaps their greatest teacher and most revered source of wisdom. I am obviously not a Druid, and I have not been trusted with full knowledge of their ways or access to their sacred sites. I do know that Glór-an-Fháidha stands the Druid college of Túr Dúlra. To the visitor with a knowledge of lore and an awareness of magic, this fallen, overgrown place is one of deep, hidden mystery.

When I passed near the walls of Túr Dúlra, I sensed whispered conversations happening just beyond my comprehension, as if the rocks, the trees, and the animals were in constant communion I could not hear. The Druids can hear it, and they understand it. They know the languages and the songs of the earth, and they can even add their voices. They draw their strength from the land itself.

For reasons you will understand later, I need an object imbued with this wild magic, grown from the earth and the rain of Scosglen. I am honored that a Druid chieftain has granted me one single leaf from Glór-an-Fháidha, a gift in recognition of my meager service to her land and people. I carry it with me now as a relic that sprouted from the very roots of Sanctuary.

There is an expression in the Fractured Peaks that does not translate well to outsiders. The people here sometimes speak of the pine-hold. I had been here for some time before I even heard anyone use the term, and I asked the old weaver woman who said it what it meant. She squinted at me for a few moments, as if trying to decide whether she would even answer me. This is what she finally said, near as I can recall it:

"You see what our houses are made from? The pinewood? Well, to be pine-held is to be safe inside when the night is longest and the cold takes fingers and toes. It is to be with family and friends, everyone healthy and safe for the present. There's a fire crackling, and candles are glowing. There's meat roasting and maybe even a pie. The ale is strong, and the laughter is loud enough to cover the howling of wind and beasts outside. That's the pine-hold. You'll know it when you're in it."

I came to Scosglen in the company of others. I now leave alone. Neyrelle follows her own path, carrying a burden I fear will be too much for her, and I can do nothing to help her. Like Donan, I must simply have faith that she will survive the ordeal. Wherever she is, I hope she is staying clear of the Cathedral's agents and avoiding cities and towns.
The Soulstone she carries will spread hatred like a contagion.

even if it is naive

I admit I find the prospect of my journey daunting. When I was a younger man, I enjoyed the thrill of the road. Travel made the world larger and smaller at the same time. The lure of distant cities and lands is one of the things that called me to the Horadric Order. Now, I am an old man who has seen too much.

The Scosglen hills to the south are becoming steep and ragged. In the distance, they break like green waves against the towering Fractured Peaks. Behind me, rolling downs tumble away toward the forests and the Frozen Sea. The air up here is already clearer, freed from the damp that oppresses the moors. It grows colder. I woke this morning to frost on the fringes of Donan's fur cloak.

The Dry Steppes lie to the southwest. I went there recently in pursuit of Elias, and I wonder what remains of the archive at the Orbei Monastery. Elias slaughtered almost every monk. The fire likely destroyed many of the relics and records. But archives like that tend to house things that can survive fires. One day, I might return there to see what is left. Today, I will continue south into the mountains, to Kyovashad.

I am tired and stopped to make camp early today. A pack of wargs attacked last night. I fought them off with a bit more difficulty than they would have once given me. I did not sleep much after that. Such encounters are often the first welcome travelers receive when entering the Fractured Peaks.

If it weren't so cold, I could smell the pine trees. There hasn't been a storm for several days, so the snow is passable. It only rises to my thighs and waist where the wind has piled drifts.

After the warg attack a few nights ago, I now build three or four small fires and sleep in the middle of them. They help with heat, and the flames also deter creatures accustomed to hunting in the long and dark mountain nights. Not all creatures. But most. I should reach my cabin sometime tomorrow.

I saw a group of Cathedral monks on the road today, and I removed myself from their path before they noticed me. Then I waited until they were gone before I resumed my journey. I'm not afraid of them. I simply didn't want the hassle or delay.

The city of Kyovashad is the perfect expression of this region. The width and depth of its moat alone suggest that it was built to repel threats of immense proportions. The walls are less those of a town than a fortress under constant siege.

Kyovashad also reflects the people who choose to live in the Fractured Peaks. Their defenses may be daunting, but inside their walls, they are generous and good-humored. They also have a deep respect for privacy. No one survives here alone, and the people of the Fractured Peaks do not have the luxury of choosing their comrades. Here, your business is your business, which is what drew me to this place. That and the silence. My cabin will be a welcome sight.

Holy Cedarwood

ᛃᛘᚻᛖᚷᚢᛖᚻᛉᚪᛟ

The Cathedral of Light has unfortunately imposed its authority on the culture of the Fractured Peaks through certain ceremonies and rituals. One of these takes place at the gates of Kyovashad, a rite of passage to enter the city. Travelers are asked to inscribe a sin they have committed on a plank of cedarwood. This written confession is then burned in a bonfire.

as churches so often do

I suspect a tradition of communal cleansing through fire has existed in these parts for some time, and the Cathedral merely subsumed the existing practice into its structure. The original ritual may have served to foster trust by expunging past offenses to more quickly integrate a newcomer or stranger into the community. It is a symbolic way of saying that one's past does not matter, so long as it remains there.

The Cathedral ritual possesses none of those qualities. Instead, it seems designed to assert dominance over the people and make them subservient and accountable to the church. That is why I refuse to perform the ceremony. There is nothing holy in it.

The Pillory of the Penitent is an even more egregious example of this.

Polearm

I have carried this blade for many years. At my age, it serves as a walking stick more often than a weapon, though it can still cleave, slash, and stab when necessary. Its design is similar to a glaive, but with two cutting edges instead of one. The blade is forged from hard steel the color of pewter and is the length of my forearm. Its heel is adorned with a version of the Horadric symbol that ends near the base. The staff is my height, with a heavy metal foot that can deliver a compelling blow if a nonlethal warning is all I require.

When I am cleaning it after a battle or honing its edges, I sometimes imagine my father's disdain for such a blade. He viewed polearms as the weapons of poor farmers, little more than glorified field implements. He preferred swords, both to forge and to wield, and that must have been on my mind when I chose this weapon from the Horadric armory. I was still rebelling then, defying him even though I had long since left his shop behind. My choice has served me well. I have slain countless demons, beasts, and human foes with my polearm. Even Borad Nahr would have to admit his admiration.

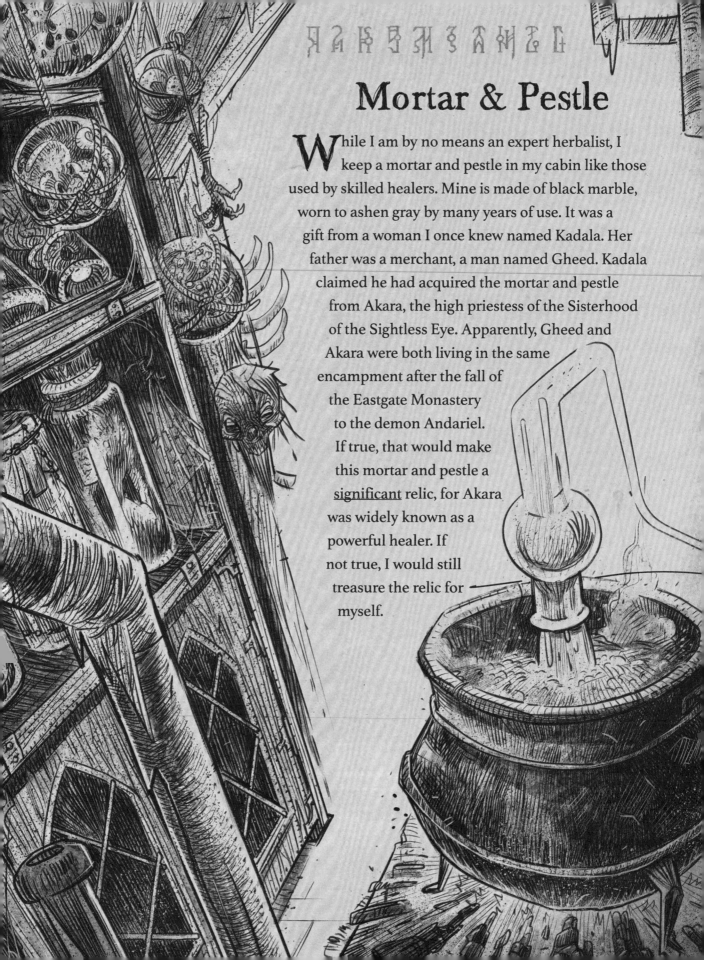

Mortar & Pestle

While I am by no means an expert herbalist, I keep a mortar and pestle in my cabin like those used by skilled healers. Mine is made of black marble, worn to ashen gray by many years of use. It was a gift from a woman I once knew named Kadala. Her father was a merchant, a man named Gheed. Kadala claimed he had acquired the mortar and pestle from Akara, the high priestess of the Sisterhood of the Sightless Eye. Apparently, Gheed and Akara were both living in the same encampment after the fall of the Eastgate Monastery to the demon Andariel. If true, that would make this mortar and pestle a significant relic, for Akara was widely known as a powerful healer. If not true, I would still treasure the relic for myself.

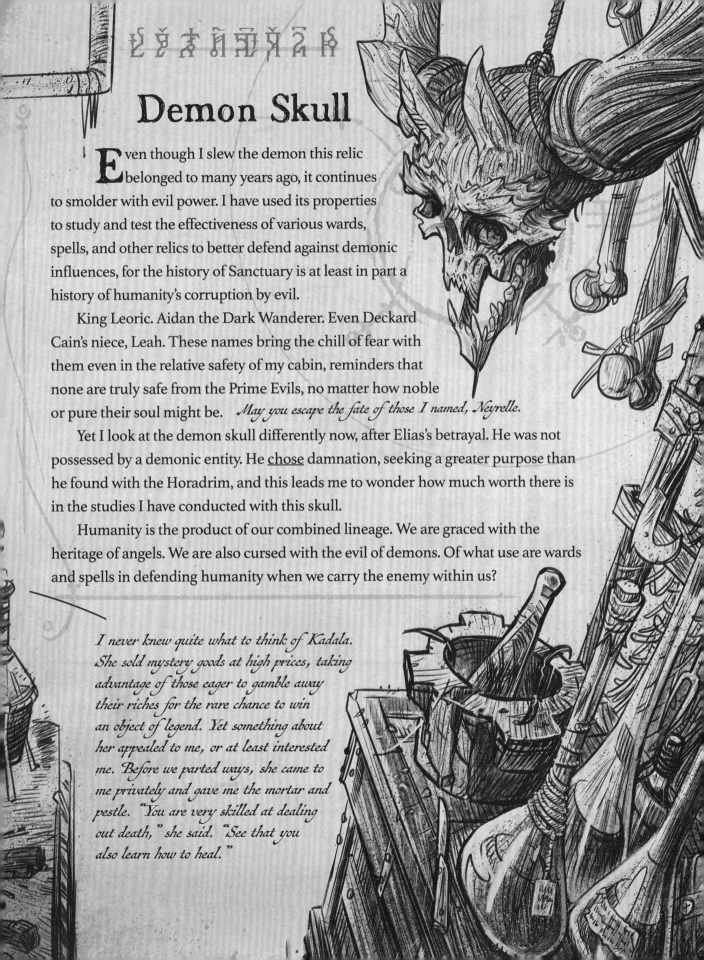

Demon Skull

Even though I slew the demon this relic belonged to many years ago, it continues to smolder with evil power. I have used its properties to study and test the effectiveness of various wards, spells, and other relics to better defend against demonic influences, for the history of Sanctuary is at least in part a history of humanity's corruption by evil.

King Leoric. Aidan the Dark Wanderer. Even Deckard Cain's niece, Leah. These names bring the chill of fear with them even in the relative safety of my cabin, reminders that none are truly safe from the Prime Evils, no matter how noble or pure their soul might be. *May you escape the fate of those I named, Neyrelle.*

Yet I look at the demon skull differently now, after Elias's betrayal. He was not possessed by a demonic entity. He <u>chose</u> damnation, seeking a greater purpose than he found with the Horadrim, and this leads me to wonder how much worth there is in the studies I have conducted with this skull.

Humanity is the product of our combined lineage. We are graced with the heritage of angels. We are also cursed with the evil of demons. Of what use are wards and spells in defending humanity when we carry the enemy within us?

I never knew quite what to think of Kadala. She sold mystery goods at high prices, taking advantage of those eager to gamble away their riches for the rare chance to win an object of legend. Yet something about her appealed to me, or at least interested me. Before we parted ways, she came to me privately and gave me the mortar and pestle. "You are very skilled at dealing out death," she said. "See that you also learn how to heal."

Horadric Amulet

Some might think the opposite of faith is doubt, but it is not. The opposite of faith is despair, and I have been guilty of it. There was even a time when I thought I had left the Horadrim behind me. The aftermath of Malthael's use of the Black Soulstone saw Tyrael gone from Sanctuary and countless dead at the hands of Malthael's Reapers. They laid waste to Westmarch, the place of my birth, and the grisly slaughter I witnessed there nearly destroyed me. With the angelic founder of the Horadrim gone, I renounced the order and sold my Horadric amulet.

After that, I withdrew to this cabin as the rest of Sanctuary fell into a period now called the Great Enmity, a time of chaos and strife between kings and warlords. I had lost faith in humanity, so I chose solitude and ale over futile efforts to bring goodness back into the world. It was in this state that I met an adventurer who proved to be a worthy comrade, and who later retrieved the amulet I had discarded. I wear it now as a symbol of my renewed hope for humanity's future, even if the Horadric Order is at its end.

That was the past I wanted to escape by coming here to the Fractured Peaks.

Bottle of Ale

Good ale can be a rare commodity in the Fractured Peaks. Arable land for grain is far from abundant in the stony vales, and the growing season is short. The local brewery offerings are sometimes drinkable. The best ale, however, is brought up from the lowlands near Kehjistan or Hawezar to the south. In the years I lived here, I admit I spent too many nights deep in a bottle and awoke in too many pigsties. At the time, strong ale provided the only relief I could find.

Though I drink less now, I have a secret stash beneath one of the floorboards that I just checked to see what might remain. I found a bottle there. Empty. Someone had taken it, opened it, drained it, and placed a letter inside before returning it to my hiding place. Someone who obviously knows me very well.

Lorath,

Please don't be angry over spilled ale. I know you, and I won't have you turning to old habits. What happened with Elias was not your fault. You know that already. Drink won't make you believe it or forget what happened. Before I left, you hinted that you might be taking a journey of your own. In your typical stubborn way, you remained maddeningly cryptic about it. So I am going to leave letters like this along my way just in case your road brings you to any of the same places. You might have been looking forward to some peace and quiet. Sorry to say you're not going to be rid of me that easily, old man. Wherever you are going, please, be watchful. Be careful. You've managed to make yourself a personal enemy to quite a few demons over the years, not to mention Prava and the Cathedral.

To answer your question, I am well. The burden is heavy, but I am bearing it.

Neyrelle

Altars of Illumination

These shrines of the Cathedral of Light sit on ancient sites in the Fractured Peaks once used by a different faith, for different rituals. The church tore down the ruins that had stood there for centuries, if not millennia, then repurposed the stone to build new structures for their own worship. This was done deliberately, to erase and replace the vestiges of what they consider to be superstitious and heretical practices. One day, the same will inevitably be done to the Cathedral's Altars of Illumination by some new, ascendant faith. It is also likely that the ruins the Cathedral tore down had themselves been built atop even older structures by people long vanished, for rituals long forgotten. That does not make any of the shrines or altars standing there meaningless. It is often not the religion or the building that matters, but the place. Sites of power can be useful, and even dangerous. Priests and monks come and go. Sanctuary remains.

Possibly an offshoot of Skatsim that found its way north.

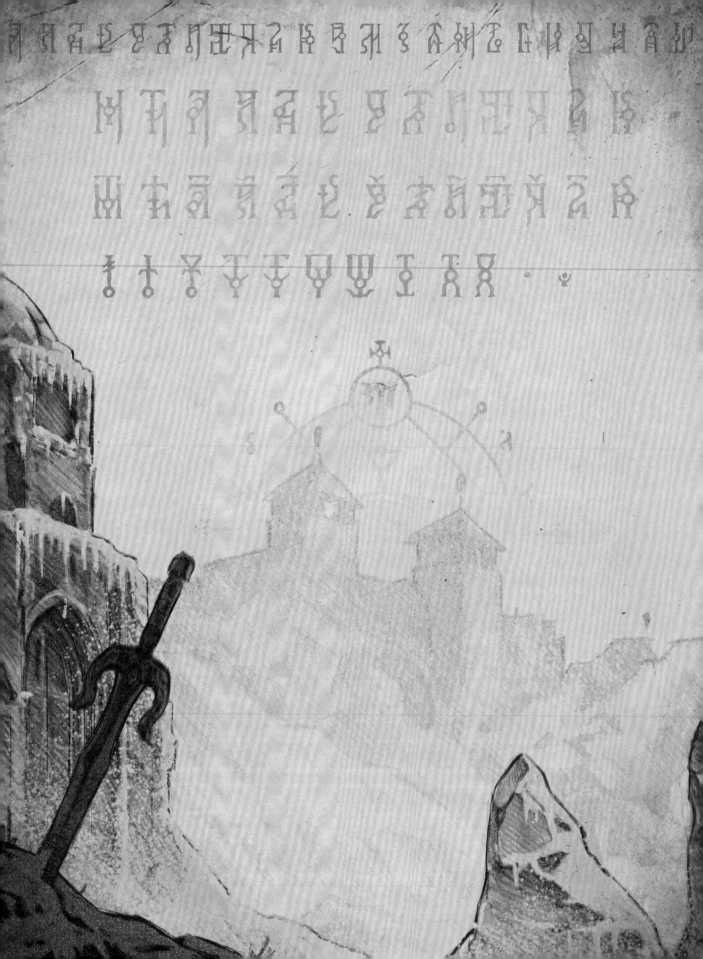

Towers of Kor Valar

ᚨᛏᚨᛜᛏᛟᛜᛟᛟᚨᛜ?

Above Kyovashad looms a glacier so ancient its first icy layers may have been laid down when the Firstborn were still young. It cracks and groans under its own massive weight, like a living, breathing thing. The fortress of Kor Valar stands upon this glacier, built by the Cathedral of Light, its towers rising to the height of the tallest mountain peaks.

Though I hold the Cathedral in disdain, I admit to once feeling a measure of awe when looking up at the imposing edifice of Kor Valar. Its spires and buttresses are graced with a dizzying majesty. Its grandeur calls to mind the angelic architecture of the High Heavens, which is unsurprising since it was for a time the dwelling place of Inarius.

His followers remain there even though he is gone, slain by Lilith. His house is now a shell, diminished by his absence, and there is something vaguely pitiful in the marching of the Knights Penitent who, though missing their general, continue to assemble and train within its walls. Their broken banner flaps in the icy wind above them, its tarnished sun drowning in a sea of blood red, reminding them of their failure.

Though chastened at present, the threat of the Cathedral remains, for a wounded animal is often more dangerous. Any Horadrim should continue to view the Towers of Kor Valar with a wary eye.

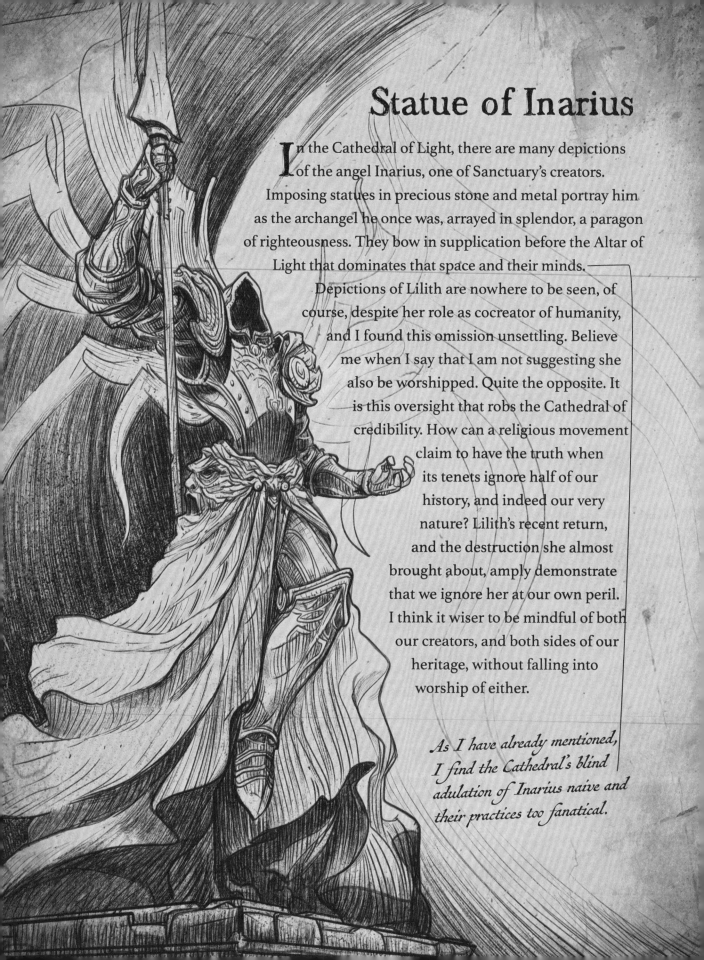

Statue of Inarius

In the Cathedral of Light, there are many depictions of the angel Inarius, one of Sanctuary's creators. Imposing statues in precious stone and metal portray him as the archangel he once was, arrayed in splendor, a paragon of righteousness. They bow in supplication before the Altar of Light that dominates that space and their minds. Depictions of Lilith are nowhere to be seen, of course, despite her role as cocreator of humanity, and I found this omission unsettling. Believe me when I say that I am not suggesting she also be worshipped. Quite the opposite. It is this oversight that robs the Cathedral of credibility. How can a religious movement claim to have the truth when its tenets ignore half of our history, and indeed our very nature? Lilith's recent return, and the destruction she almost brought about, amply demonstrate that we ignore her at our own peril. I think it wiser to be mindful of both our creators, and both sides of our heritage, without falling into worship of either.

As I have already mentioned, I find the Cathedral's blind adulation of Inarius naive and their practices too fanatical.

Vhenard's Chalk

Vhenard was Neyrelle's mother. Like Airidah and Nafain and countless others before, she became enthralled by Lilith, lured by promises of knowledge and power. She followed Lilith down into the abandoned mine and caverns beneath the Fractured Peaks, to an ancient buried city of the Firstborn. Toward the end of Vhenard's descent, she began to chronicle her journey, writing a screed in chalk along the way. She felt so compelled to make her record that after she had used her chalk to the last nub, she began to write in her own blood.

For whom did she scrawl her grisly record, I wonder. I would assume she wrote at least in part for her daughter, to explain and justify herself. Those who are most desperate to tell their tales are often those who know that other versions of their stories will be told. They seek to have the final word, and to be understood. Some part of Vhenard must have known and feared what others would think of her actions, but instead her frantic scribbling only confirmed how far she had fallen. This blood-flecked scrap of chalk is now a cursed token of her madness and denial.

often in vain

including her own daughter

Vigo's Wealth Charm & Penitent Armor

Zealotry often leads to needless suffering and wasted lives. Vigo was a Knight Penitent in service to the Cathedral of Light. He was also a gambler, and possibly a fool. All Vhenard needed to offer him was the simple bribe of a wealth charm, and he granted her access to the mines that led down to the Path of the Firstborn. He took little notice of Vhenard's companion, the demon Lilith in disguise, and only later learned of the role his failure had played in the suffering and death she would cause. To his credit, this realization sent him on a mission of penance and redemption.

Beyond the Path of the Firstborn, and beyond the Black Lake, there is an ancient necropolis almost as old as Sanctuary. It was there that Vigo found his salvation by leaping into battle against the guardian of that dead city. He wore a type of holy armor that I have only ever heard about. This Penitent Armor is fitted with cruel spikes pointed inward. With every strike Vigo gave and every blow he received, his own armor pierced his flesh, doing the work of his opponent. Even with such deadly encumbrance, his prowess in battle helped him defeat the Necropolis Guardian.

Thus, Vigo died for his sins. Or at least, that is what he believed, and because of that, he felt redeemed. I believe he could have survived had he charged into battle wearing sensible armor forged to save his life. Whether his efforts would have absolved him of wrongdoing had he lived is a pointless question now that he is gone.

Before he died, Vigo gave the wealth charm to Neyrelle, and I believe she has it now, no doubt a painful reminder of her mother's fall. I hope it is proving at least somewhat useful to her.

I wonder if it can even be called "armor" at all when considering that such protection is almost always worn to prevent injury, not cause it.

It should keep food in her belly, at the very least, so long as she remembers to eat.

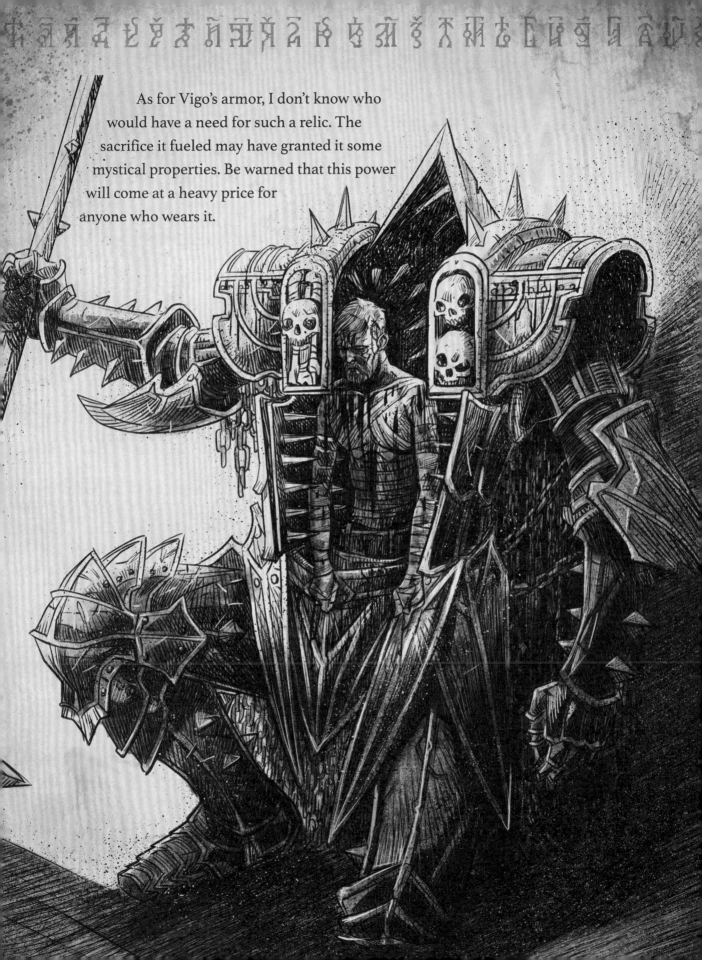

As for Vigo's armor, I don't know who
would have a need for such a relic. The
sacrifice it fueled may have granted it some
mystical properties. Be warned that this power
will come at a heavy price for
anyone who wears it.

TUMORS OF HATRED

Lilith was the daughter of Mephisto, Lord of Hatred, and so she was the Daughter of Hatred. Where she went, the toxin of her presence seeped into the ground, infecting it with her corruption. Down in the necropolis of the Firstborn, Tumors of Hatred grew in her wake, demonic abscesses filled with bile, puss, and noxious gasses. They continued to emanate the same hatred that Lilith spread, aggressive cankers that turned Sanctuary against itself.

Though Lilith is gone, hatred is not. It is simply less visible, more insidious, and it can spread just as vigorously if left unchecked. You may not see any tumors growing, but that does not mean you will be safe from their influence. Calls to hatred are often carried or accompanied by messages of fear, the domain of another Prime Evil, the Lord of Terror. Fear and Hatred lead to Destruction.

I dread the possibility that I will find new Tumors of Hatred growing where Neyrelle has traveled.

Amethyst Ring

ꓤꓤꓤ

like those of the scoundrel

This relic isn't named in the manner of more legendary rings. It isn't ornate or richly made. I acquired this ring, and I have held on to it these many years, simply because I find its gemstone beautiful.

It is a large amethyst of intriguing depth and color variation, with a ribbon of smoky purple that seems to coil through a bright and clear violet sky. These imperfections make it unsuitable for inclusion in more powerful jewelry, and someone else likely would have removed it from its setting to reforge it and increase its purity. The same qualities that would devalue it to others are the very reasons I treasure it. It is a token to me, in that its power is in its meaning.

It is a gem unlike any I have ever seen. When I look into it, I am reminded that the hard bones of Sanctuary can still yield things that are beautiful simply for their own sake. If the Leaf of Glór-an-Fháidha is an expression of what can grow from Sanctuary's water and earth, then this amethyst is an expression of what can be made by the fire and pressure in Sanctuary's foundations. Three of the primary elements. And when I add this ring and its gemstone to the leaf, I have a suitable base upon which to build the protective spell this book requires.

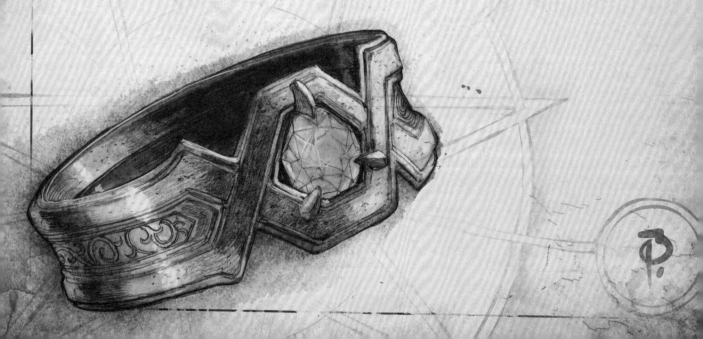

Neyrelle,

You owe me a bottle of ale, and not the cheap stuff. I trust you'll make good on that debt one day, and we shall enjoy a drink together. Until then, I admit that finding your letter gave me more enjoyment than the bottle's original contents would have. I leave this note in place of yours in case you return to this cabin and look to see if I found the message you left for me.

It was odd coming back here. Other than the ale you wasted, my cabin was left untouched in my absence. There are few other places in Sanctuary where that would be the case, everything just as I left it. The evidence of a life I once had but can't truly return to. This house now feels like it almost belongs to someone else. I'm about to say farewell to it once again, perhaps never to return.

You guessed correctly that I am traveling. I am compiling a catalogue of relics as I go. I'll say no more about it for now. It's possible our journeys may take us to some of the same places—if so, I hope to find more letters from you waiting for me.

Go safely on your way, child.

Lorath

The air is warming. There are now trees with leaves among those with needles. The snows are gone. Though I'm not quite out of the mountains, I no longer need to wear Donan's cloak. After tonight, I'll pack it away. Extra weight, but necessary. If my journey takes me where I plan to go, I'll need it again.

I caught the first glimpse of Hawezar today. Just a narrow wedge of vibrant green between two gray peaks to the south. Not far now. Several more days, and I'll be down in the swamps, swatting at biting flies and wishing I was back in the mountains.

I do wish I was back in the mountains. Hawezar is hot and humid. The swamps are dense and disorienting. There are roads—narrow and often washed out for stretches that force me into snake-infested waters. At night, the noise of insects, frogs, and other creatures is almost deafening.

I stumbled across a grave marker for a Crusader today. It was overgrown and almost worn away. No doubt the dead warrior's apprentice took up the slain master's armor and sword and carried on in the futile search for Akarat, the mystical founder of the Zakarum faith.

also now dead

The region of Hawezar is nominally part of the Kehjistan empire, but its territory is inaccessible and sparsely populated. Distant powers in Kurast or Caldeum have little control or influence here over the witches and other denizens of the swamps. I'm hoping to reach the city of Zarbinzet soon, to obtain what I need, and then be gone from this place as quickly as possible. I have no desire to encounter the Tree of Whispers again before my time is due.

My sister found a ribbon
 and put it in her hair,
but the ribbon had a venom
 that was more than she could bear.

This Hawezar children's rhyme is obviously a reference to the many types of venomous snakes found in the region, a fairly standard warning rehearsed to remind children not to go near any serpents or attempt to pick them up. Travelers might be less likely to hear this spoken by members of the snake cults who also lurk in swamps.

Band of Hollow Whispers

This ring is made of gold, with a crimson band and a pale gemstone surrounded by a setting of four sharp talons projecting upward. The jewel is unlike any that I know of, cloudy with a subtle glow that seeps out like candlelight through fog. The ring's enchantment increases the vitalities and faculties of the one who wears it. The name of this band is derived from another, more singular quality that it possesses.

Periodically, the ring releases a vengeful spirit capable of haunting the wearer's enemies, and this apparition will inflict considerable harm and injury, even killing weaker foes. It is unknown whether the ring is a prison that contains these souls or merely a gateway for spirits to enter our realm from another. Either way, such magic would obviously suggest an origin involving necromancy.

The Necromancer Zayl wrote that he did not believe the ring to be entirely the creation of a Priest of Rathma. He suspected it was produced by a partnership between a powerful Necromancer and someone highly skilled in the jeweler's art. Zayl thought the famous artisan Covetous Shen a likely candidate, though I am not convinced. The ring appears quite ancient, even older than the oldest estimates of Shen's age.

If the gemstone is a prison, it would almost seem to be a lesser kind of Soulstone, which points to a mage like Zoltun Kulle as its creator, he who forged the Black Soulstone. If not Kulle's work, the Band of Hollow Whispers might at least be the creation of someone familiar with that fallen Horadrim's research, possibly having accessed his vast hidden library.

and Horadrim

assuming he is, in fact, a mortal

Moonlight Ward

Wizards have the ability and skill to channel arcane energy that could disintegrate anyone unwise enough to summon it without training. Even the mages from more traditional schools and philosophies view the wild power of the wizard as unpredictable, vulgar, and heretical, and would be reluctant to attempt such spells. That said, there are a few ways a non-wizard can utilize arcane energies, should that be desired, often through the mediating control of a relic.

The Moonlight Ward is one such amulet. It is made of precious metals in the shape of a crescent moon, pointed downward like the horns of a bull. Rays of gold and silver descend from a simple geometric pattern in the middle of the moon, with a small eye at the center. A wizard wearing this relic will find their spells do greater amounts of arcane damage. Those who are not wizards will discover that as they strike their enemies through more customary means, the amulet produces shards of arcane energy that orbit the wearer. These fragments explode when enemies come within range, inflicting the same type of damage as a wizard's spells. —— *But without the risk of disintegration!*

Jar of Eyes

There are many witches living in the swamps and fens of Hawezar. Their magic makes use of the natural world around them differently than how the Druids do. They use spell books, lore books, and rituals, free from the order and discipline of the mage schools. They practice dangerous magic, at times, and often live in isolated hovels away from towns and settlements. Those seeking help from them should remember that even though they may appear willing to offer spells, their aid will often come at a price.

With all this in mind, none could mistake Valtha as anything but a witch of Hawezar, and she had in her hut exactly the kinds of ingredients one would expect. A gruesome jar of eyes stood out to me for the sheer variety of oracular organs contained within it. Eyes small enough to have come from spiders and hummingbirds filled the gaps between those the size of giant vulture eggs. Some of the eyes glistened white as pearls, while vivid red veins covered others. Reptile eyes rested next to the eyes of birds, fish, and mammals. I understand the basis for the type of magic that calls for such ingredients. To take the eyes of something is to take what that being has seen. To take its awareness, its perception, and then use it. Eyes are potent symbols, and as I looked at the jar of eyes in Valtha's hovel, I almost felt it looking back at me.

or curses

Valtha's Cauldron

A pungent steam filled Valtha's hovel, rising from a cauldron bubbling over a low fire in her hearth. The vapors burned my nose and caused my vision to ripple and waver. Age and long use had turned the iron vessel's belly black with soot, and the residue of previous concoctions lined the inside with stains of vivid and unnatural colors.

Cauldrons are both common and mysterious. You can find them in most homes and kitchens and purchase them in almost any market. Yet for all their simplicity, they possess a subtle but staggering alchemical power. They take in what we feed them and turn those ingredients into wholly new substances. The cook knows how to use this ability to craft a tasty pottage or a stew from the most meager of scraps. The witch knows how to employ a cauldron in the making of much more potent brews.

My need would have to be very great indeed before I would accept any potion from Valtha's cauldron. I am sure there are some who have benefited from her skill, and even more who have been harmed by it.

remarkable that poisons, fulminates, and potions of healing and replenishment all come from the same pot

Purified Quicksilver

Certain types of magic are more art than science. That is why the practice of various spells improves their quality, and why some mages are more naturally gifted than others. To brew an effective potion, careful and consistent attention to the recipe is all that is required. To repair and tune a Soulstone is something else entirely.

When we decided to use Astaroth's Soulstone to trap Lilith, I assumed Donan's knowledge had equipped him for the task. I assumed that if we acquired the proper ingredients and reagents, the spell would work, including the purified quicksilver we obtained from Valtha, the Hawezar witch. I was wrong. As Taissa helped Donan see, the spell would fail so long as Donan remained broken and compromised by his grief.

When performing magic, follow the recipe, and do not forget that you are often one of the ingredients.

Valtha's Spell Book

I am accustomed to holding the tomes of the Horadrim, books bound with artful skill in supple leather, some of them ornamented with gems and carved bone, or trimmed with precious metals. The libraries of the Horadrim have always been treasure houses, not just of wisdom but also material wealth. Valtha's spell book presented a very different kind of assemblage, as do most texts kept by the witches of Hawezar.

Its cover was of a type of swamp skin I couldn't identify. Fungus stained its tattered and uneven pages, between which sprouted twigs and insect legs. A greasy scrap of fishnet bound the whole thing together, giving the impression of something that had been caught in the wild.

Do not make the mistake of judging such books inferior by comparing their appearance to more refined tomes. The contents of such spell books are treacherous and bewildering, their magic sophisticated and powerful. The same principle applies to the witches themselves.

possibly snake, or even maggot hide

Taissa's Ingredient Pouch

Taissa is another witch of Hawezar, a talented younger rival to Valtha. She carries with her a leather satchel, to which she is always adding ingredients she gathers for her spells and potions as she crosses the fens. She consults no reference or text as she does this. She recognizes each tree, algae, flower, and fungus by sight and smell, calling them by old names handed down through numerous generations. Her working knowledge of the land is impressively vast. Indeed, the whole swamp is her lore book.

She is also wise for one her age, and her skills proved essential in stopping Lilith. Our plan required a Soulstone, the preparation of which largely fell to Donan, but he found his faculties impaired by insurmountable grief. It was the healing ministrations of Taissa that finally brought him back to himself, allowing us to press forward.

I have mentioned Taissa before, the poor girl Elias carved into when he attempted to summon Andariel. Though we succeeded in stopping that ritual, I fear Taissa will be forever scarred by the experience, both physically and mentally. I hope she is healing as best she can. She serves the Tree of Whispers, and were it not for that fact, I would seek her out to see how she is doing.

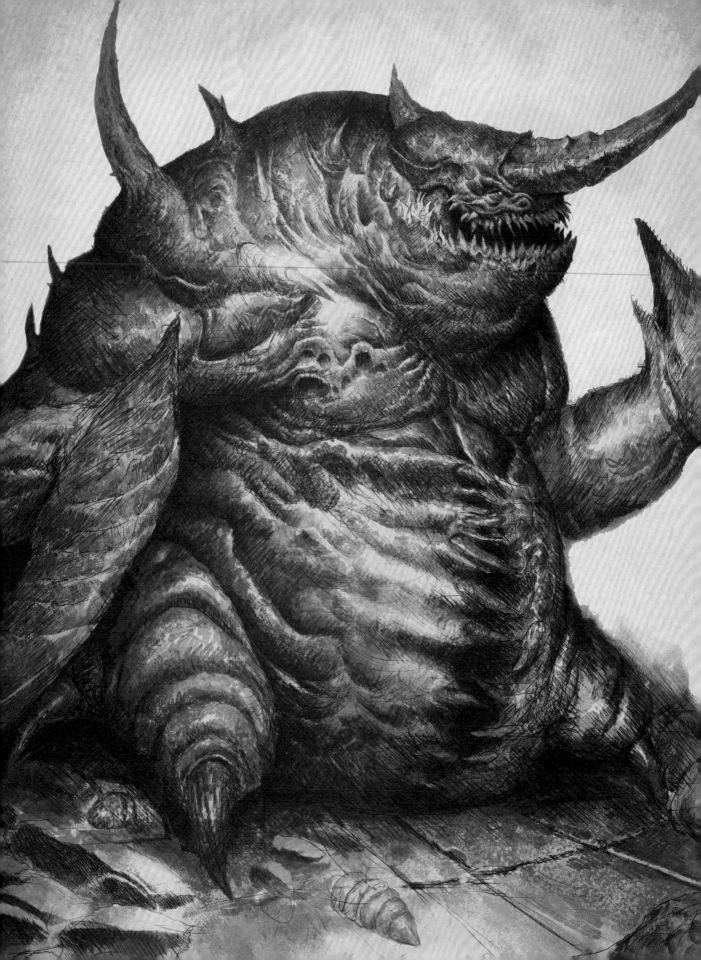

Maggot Queen Ichor

The potion Taissa brewed for Donan required several ingredients found in the marsh and swamp, and the quest to obtain them proved somewhat difficult. In addition to snakemen and bloated undead, there are blood and plague maggots lurking in the putrid waters. Though dangerous to travelers, remember that maggots have their purpose. In consuming that which is rotten and infected, they can be used to clean wounds and clear away decay. Their ichor allows them to digest matter that nothing else will consume. Perhaps it is this property that made the ichor of the Maggot Queen suitable for Taissa's potion, granting Donan the ability to deal with his festering grief.

Yellow Lotus

This rare flower grows in the farthest reaches of Hawezar's swamps. Its lily pads grow to spans the width of wagon wheels. When you come upon them in the dim gloom under the swamp canopy, the yellow lotus blossom at the center of the pad seems to smolder with the light of a campfire on the water. To pluck the flower, one must venture out from the shore, facing dangers from serpents, bats, and swamp spawn. Only those brave enough to obtain this lotus will be rewarded. Its petals are apparently useful in a number of spells, including the ritual that helped Donan recover.

Swamp Sage

This herb has an intense, almost smoky fragrance that can be detected from several yards away. It grows in thick bushes amidst more dangerous poisonous plants and thorny vines. As with the yellow lotus, to harvest swamp sage will require the traversal of lands infested with bloodhawks, woodwraiths, and spiders. Also note that the witches of Hawezar face these threats regularly in foraging the ingredients needed for their spells, which is sufficient to prove the strength and tenacity of these cunning folk.

Sigils of Dendas

I must rely on Donan's expertise here, as the Sigils of Dendas relate to Soulstones and their attunement, a subject about which he knew much more than I. The following excerpt is taken from his journals:

"The Sigils came about through careful observation and the discovery by Dendas that Soulstones have facets. Not the physical, internal planes that jewelers use to cleave and refine gemstones. Soulstones possess energy facets, which Dendas believed were remnants of the currents of creation that flowed through the Worldstone. These are somehow instrumental in containing an essence within a Soulstone, almost like the walls and bars of a prison. The six Sigils work to align these facets, creating stability and coherence. It's an intricate, beautiful process. Without it, the Soulstone may be unbalanced, unstable, leading to structural failure. That is why the work of attunement must only be undertaken with complete, undivided attention. The Sigils demand absolute clarity of mind."

Timue's Tea

Those who dwell in the swamps of Hawezar for too long can become afflicted with any number of diseases, plagues, and rots. Some conditions cause agony and quick death, while others lead to a slow, peaceful demise almost beautiful in its horror. Some swamp seeds, if ingested, can take root inside the body. Flesh is soil to such plants, providing nourishment to the seedling as it enters muscles, organs, veins, and the brain. Over time, green tendrils emerge through the victim's skin from within. Even then, the poor soul does not seem to be in any pain. That was the case with an ancient crone named Timue when we met her. Both blessed and cursed, the swamp has given her an unnaturally long life. As with others so afflicted, one day she will respond to an inner, wordless call from the plant inside her and remove herself from her home to the swamp. There, she will wander, shambling in search of a suitable spot of earth, and when she finds it, she will plant herself. Before long, it will appear as if the tree standing there has always been a tree, dropping its fruit and seeds.

Beware of tea made from such offerings.

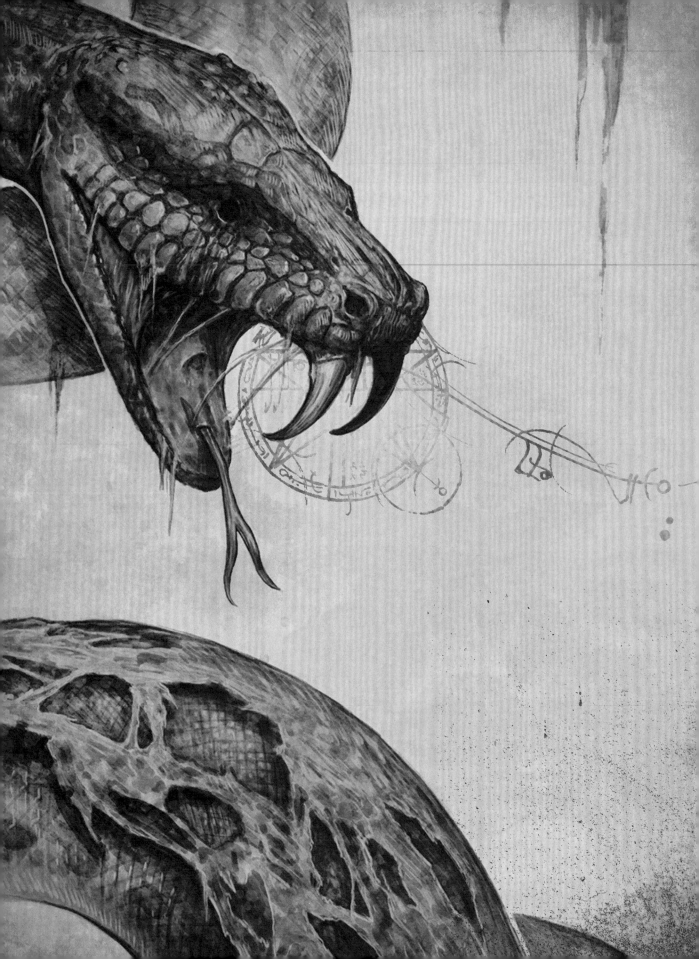

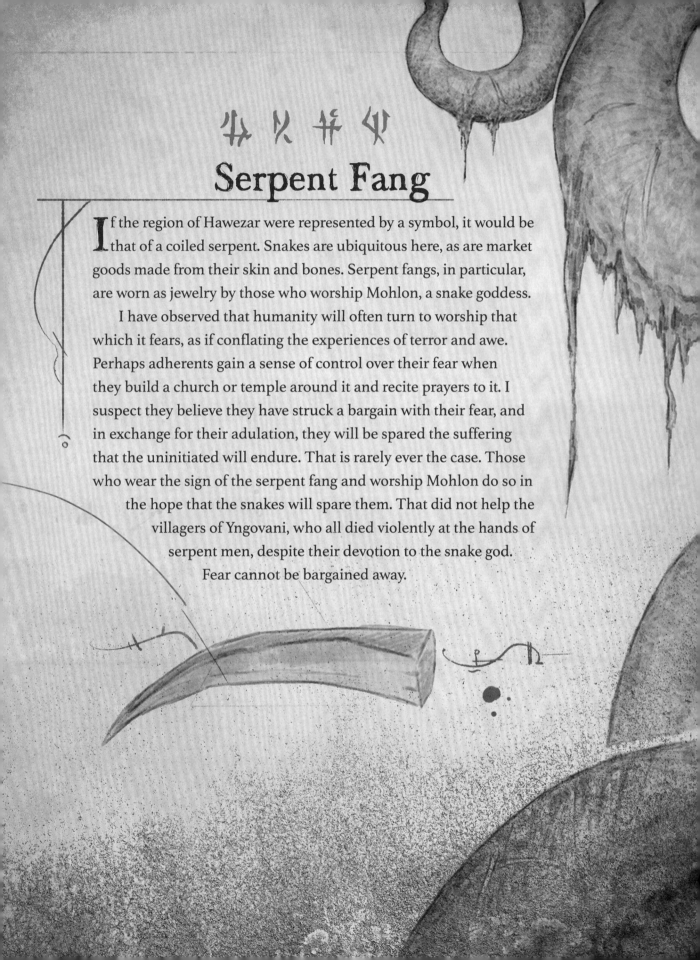

Serpent Fang

If the region of Hawezar were represented by a symbol, it would be that of a coiled serpent. Snakes are ubiquitous here, as are market goods made from their skin and bones. Serpent fangs, in particular, are worn as jewelry by those who worship Mohlon, a snake goddess.

I have observed that humanity will often turn to worship that which it fears, as if conflating the experiences of terror and awe. Perhaps adherents gain a sense of control over their fear when they build a church or temple around it and recite prayers to it. I suspect they believe they have struck a bargain with their fear, and in exchange for their adulation, they will be spared the suffering that the uninitiated will endure. That is rarely ever the case. Those who wear the sign of the serpent fang and worship Mohlon do so in the hope that the snakes will spare them. That did not help the villagers of Yngovani, who all died violently at the hands of serpent men, despite their devotion to the snake god. Fear cannot be bargained away.

Mystic Incense

The cult of Hawezar worshipped Mohlon, though she was no demon, nor a goddess. She was a hideous and powerful creature of the swamp who dwelt in a pit where she accepted offerings from her supplicants. These tributes included trinkets, baubles, food, drink, and mystic incense. It seems that Mohlon accepted these gifts and grew comfortable in her nest. Whatever being sired, birthed, or created her, whether she hatched from an egg or wriggled from the mud, it seems she forgot her origins and came to believe in her own divinity. True gods do not die as easily as she did. Mohlon was but the weakened and diluted progeny of even greater serpents that still slither through the farthest reaches of the Hawezar swamps. Reserve your mystic incense for them.

Snake Altar

Where there is a cult, there is inevitably an altar, and the snake cult of Hawezar is predictable in that way. I do not speak of their temple to Mohlon. Their true altar can be found deep in the Writhing Mire, shaped from the swamp itself, vines and roots entangled like a nest of vipers. You will find no crude statues here, no vulgar effigies. This place is ancient and primordial. This altar grew to its mythic stature from the mire and the trees in reverence of Rathma's serpent, sometimes called Trag'Oul.

When mystic incense is burned here, you draw the attention of old eyes. You risk annihilation by an elder being to whom you are insignificant, who may grant your desire, or consume you, according to its own ineffable designs. You summon a serpent in the image of Trag'Oul. It is possible you will go mad in the presence of such vast knowledge and wisdom. Consider all of that before you seek to worship at such a place. Or call forth such an entity.

Wooden Coffin

If you seek the sunken Temple of the Deathspeaker, there is only one vessel capable of carrying you there. First, you must traverse the swamps of Hawezar until you reach the Sea of Light far to the east, where creaking shipwrecks line the perilous shore. Once there, you will have the drowned Undead to contend with. If you survive, and if you are fortunate, you will find no boat waiting for you at the last pier—rather, a coffin bearing the symbol of Rathma. If you are bold enough to board this craft, it will take you beneath the waves to the submerged Necromancer Temple.

or unfortunate

I must warn you of my suspicion that few who reach that place ever leave it, for its secrets are protected by undead guardians and risen Priests of Rathma who do not suffer trespassers. Therefore, be certain of your reasons and need before venturing there.

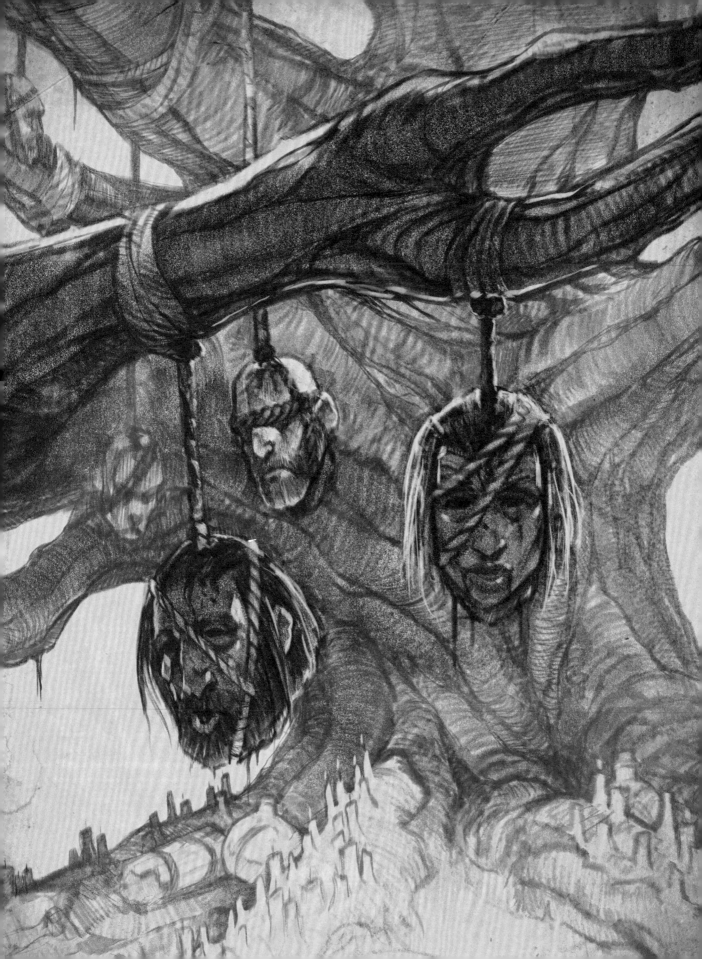

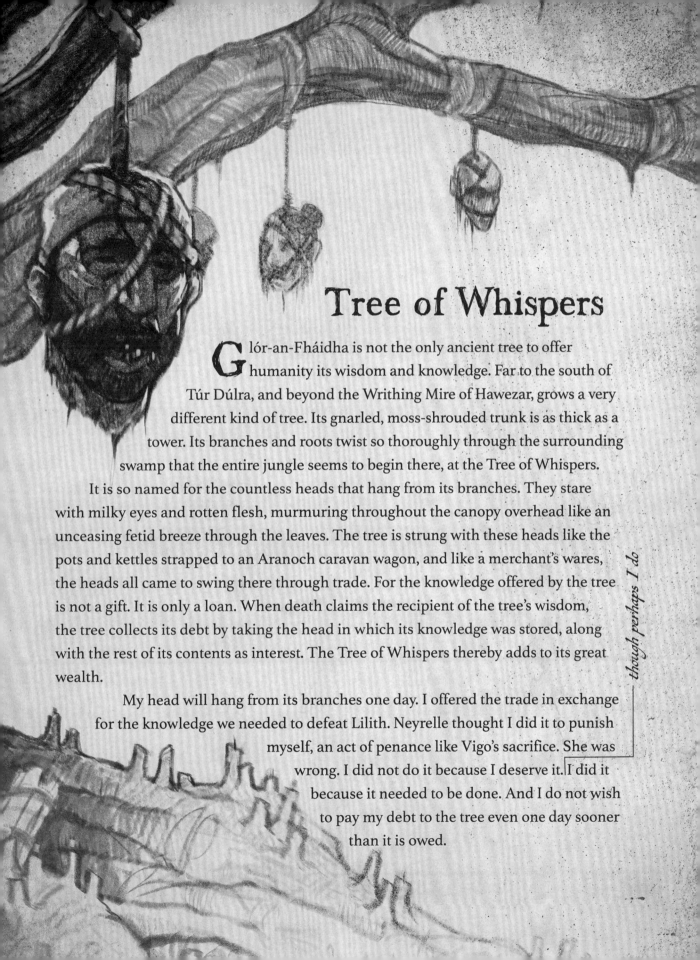

Tree of Whispers

Glór-an-Fháidha is not the only ancient tree to offer humanity its wisdom and knowledge. Far to the south of Túr Dúlra, and beyond the Writhing Mire of Hawezar, grows a very different kind of tree. Its gnarled, moss-shrouded trunk is as thick as a tower. Its branches and roots twist so thoroughly through the surrounding swamp that the entire jungle seems to begin there, at the Tree of Whispers.

It is so named for the countless heads that hang from its branches. They stare with milky eyes and rotten flesh, murmuring throughout the canopy overhead like an unceasing fetid breeze through the leaves. The tree is strung with these heads like the pots and kettles strapped to an Aranoch caravan wagon, and like a merchant's wares, the heads all came to swing there through trade. For the knowledge offered by the tree is not a gift. It is only a loan. When death claims the recipient of the tree's wisdom, the tree collects its debt by taking the head in which its knowledge was stored, along with the rest of its contents as interest. The Tree of Whispers thereby adds to its great wealth.

My head will hang from its branches one day. I offered the trade in exchange for the knowledge we needed to defeat Lilith. Neyrelle thought I did it to punish myself, an act of penance like Vigo's sacrifice. She was wrong. I did not do it because I deserve it. I did it because it needed to be done. And I do not wish to pay my debt to the tree even one day sooner than it is owed.

though perhaps I do

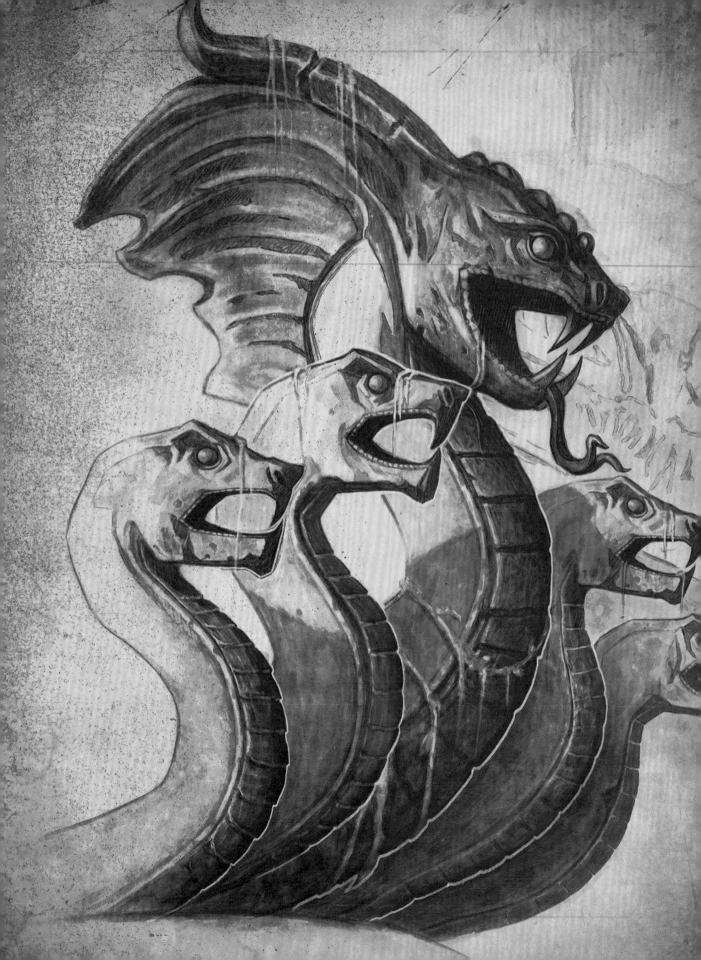

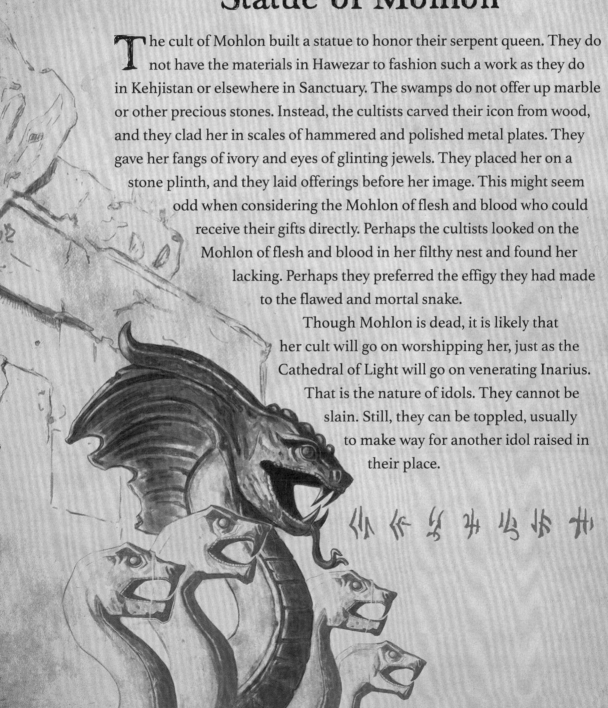

Statue of Mohlon

The cult of Mohlon built a statue to honor their serpent queen. They do not have the materials in Hawezar to fashion such a work as they do in Kehjistan or elsewhere in Sanctuary. The swamps do not offer up marble or other precious stones. Instead, the cultists carved their icon from wood, and they clad her in scales of hammered and polished metal plates. They gave her fangs of ivory and eyes of glinting jewels. They placed her on a stone plinth, and they laid offerings before her image. This might seem odd when considering the Mohlon of flesh and blood who could receive their gifts directly. Perhaps the cultists looked on the Mohlon of flesh and blood in her filthy nest and found her lacking. Perhaps they preferred the effigy they had made to the flawed and mortal snake.

Though Mohlon is dead, it is likely that her cult will go on worshipping her, just as the Cathedral of Light will go on venerating Inarius. That is the nature of idols. They cannot be slain. Still, they can be toppled, usually to make way for another idol raised in their place.

Scale of Rathma's Serpent

I came back to Hawezar because I needed a piece of the swamp. Despite my personal dislike of this land, it is part of Sanctuary, as are the beings that dwell here. I do not refer to Mohlon—rather, to the greater serpents who came before her.

One of those beasts appeared at the Snake Altar, a wyrm in the image of Trag'Oul, the cosmic dragon who is tied to our world but also dwells outside our world, a celestial entity entwined with the fate of Sanctuary. Trag'Oul is the serpent of Rathma, and Necromancer lore associates this being with harmony among the five elements of fire, water, earth, air, and time. I returned to the Snake Altar hoping to find a scale of one of his children, and after spending several days scrambling through the jungle, wet and irritated, I found many.

The molted skin was so wide and stretched so long that I mistook it for a pale footpath in the gloom. When I realized what it was, I quickly cut a single scale from it and left that place behind. I have added this emblem of balance to the elements represented by my Amethyst Ring and the Leaf of Glór-an-Fháidha.

I'll be glad to put Hawezar behind me. That said, I'm almost afraid I'll get lost on the way out and end up trapped until that tree takes my head.

I try to avoid lighting campfires here in the swamp. I don't need them for warmth, and they only seem to draw more biting and stinging pests to me.

Without a fire, the swamp is dark. Darker than any other forest I have seen. If the moon or stars are out, none of their light reaches me.

The way the paths wind back and forth makes the journey feel interminable. I must be making some progress westward, slowly, because the ground is drying out. The air is drying out. The clouds of flies are thinning. The mountains are in sight, almost maddeningly close. It may still be many days before I am out of the fens entirely.

A final parting gift from Hawezar today. A group of snakemen attacked. This far west, they must have been tracking me for some time, trying to decide whether to try me. They made the wrong choice. Those I didn't kill fell back into the swamp. I am quite sure I won't see them again, and they might even think twice before assaulting the next old man they encounter.

I am out of the swamps at last. I pushed a bit farther today, until after the sun had set and I had to make camp in the twilight, just to finally be free of Hawezar. From here, I continue upward into the foothills and cross the mountains into Kehjistan. My route will take me to Caldeum first, and then south to the Kurast Docks, where I will buy passage on a ship crossing the Twin Seas. Or at least, that is the plan.

Kehjistan
Crucible,
first land
Lies shattered
In the desert sand

This poetic fragment refers to Kehjistan's ancient history as the first human civilization in Sanctuary, but also its decline and collapse.

Kurast!
 A beacon of brightest light
 Shining for the World.
 A wondrous city of gold
 And perfumed palaces.
Kurast!
 Your high towers gleam
 In the bronze light
 Of a sun that will never set
 On the glory of your rule.
Kurast!

This is just one small part of a poorly crafted poem by a long-dead and forgotten writer. It is an absurdly lengthy and ecstatic tribute to the city of Kurast, which now lies in ruin, just like Corvus and Viz-Jun and Caldeum and Old Tristram and countless other cities whose residents no doubt once believed their prosperity would last forever.

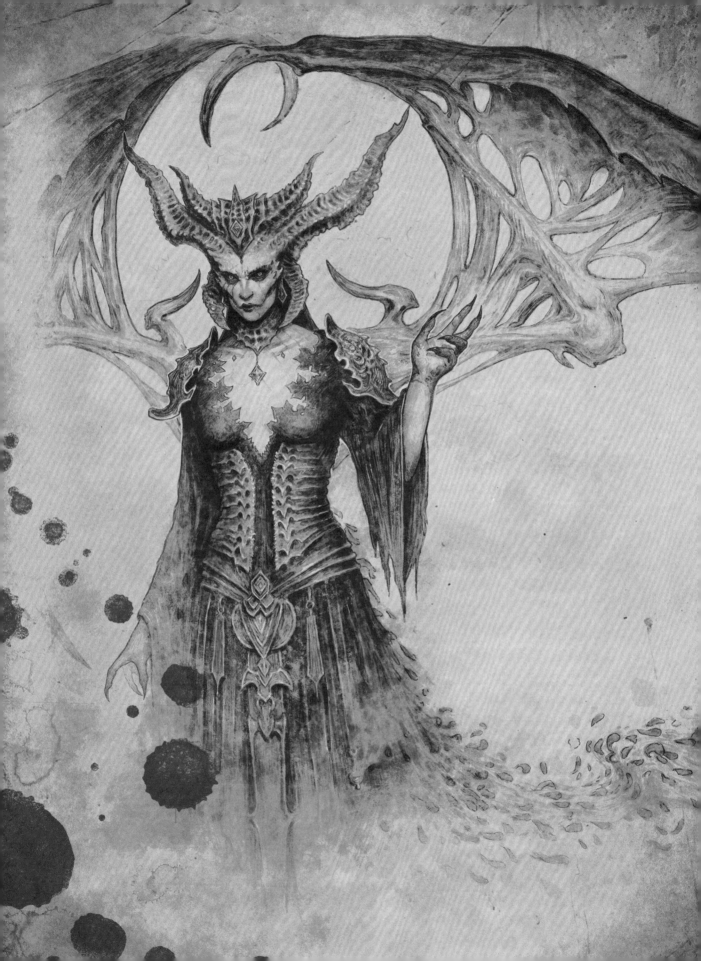

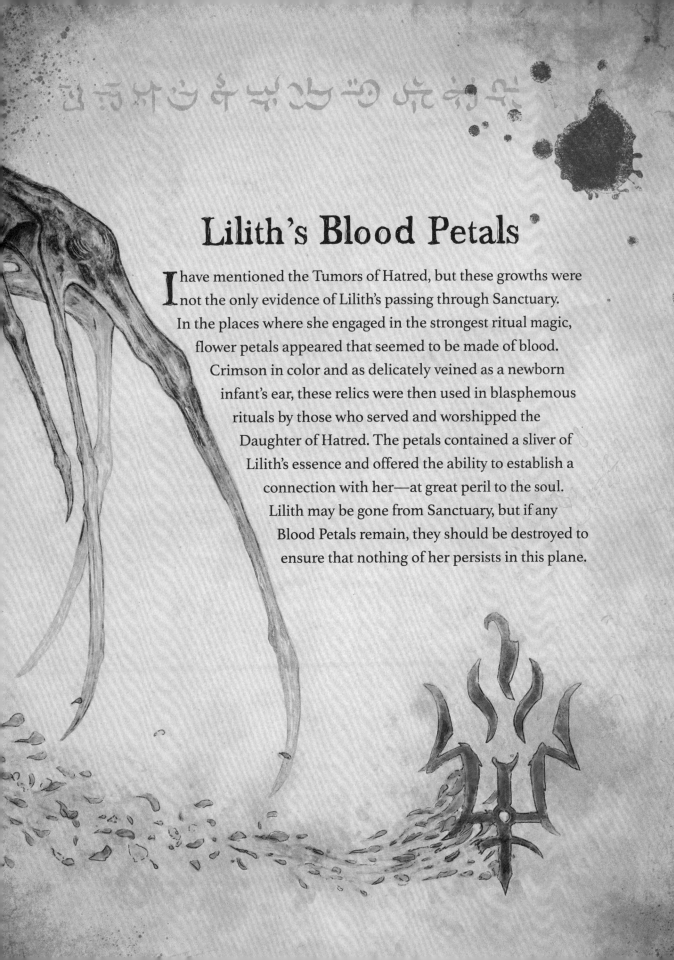

Lilith's Blood Petals

I have mentioned the Tumors of Hatred, but these growths were not the only evidence of Lilith's passing through Sanctuary. In the places where she engaged in the strongest ritual magic, flower petals appeared that seemed to be made of blood. Crimson in color and as delicately veined as a newborn infant's ear, these relics were then used in blasphemous rituals by those who served and worshipped the Daughter of Hatred. The petals contained a sliver of Lilith's essence and offered the ability to establish a connection with her—at great peril to the soul. Lilith may be gone from Sanctuary, but if any Blood Petals remain, they should be destroyed to ensure that nothing of her persists in this plane.

I know of at least one delegation of Horadrim sent there by Tyrael, and they carried a powerful gift with them. None have returned, nor have they been heard from since.

Sightless Eye

According to legend, this relic once allowed a Firstborn of Sanctuary named Philios to communicate in secret with Lycander, an angel in the High Heavens. This link threatened Sanctuary with discovery by the Angiris Council, so Lycander ended her communion with Philios and told him to hide the Sightless Eye.

Philios placed the relic on the isle of Skovos in the Twin Seas, where his twin daughters eventually discovered it. These same sisters also founded the Askari people, who dwell on those islands to this day. They are called Amazons by some, renowned for their deadly prowess with bow, javelin, and spear.

The Sightless Eye, the most sacred relic of Askari culture, is no longer on Skovos. During an incident of sectarian conflict, a renegade group of Askari women absconded with the Eye and left the island. They settled in Khanduras, at the Eastgate Monastery, and called themselves the Sisterhood of the Sightless Eye. Their high priestess, Akara, was the same woman who supposedly once owned my mortar and pestle.

In addition to communication with the Heavens, the Sightless Eye could scry far distant places and even see into the future. Most recently, the Eye allowed us to observe Lilith from afar, but we soon learned that she could also see us.

If you find it odd that a relic offering the ability to see would be called "sightless," remember that sight is not only a product of the eyes. True perception also requires a mind to interpret what the eyes see. *And hopefully the wisdom to act.*

Horadric Ritual Tome

The Horadrim acquired vast troves of relics and texts throughout their long history. Many of these collections have been lost, but in the Mistral Woods there is a Horadric Vault that had been preserved well enough to remain useful. It contained a large store of objects, tools, and knowledge, and was guarded by powerful wards and spells.

perhaps for the better

One of the books held in the Vault was a Ritual Tome. It was created by Elias as he studied and compiled the writings of Rathma, the first Necromancer, and therefore its spells relate primarily to working with the dead. I would ordinarily trust nothing created by Elias; however, this book is not truly his work and may prove useful to those who wish to benefit from the wisdom Rathma received from Trag'Oul. Neyrelle used it to contact the spirit of her mother, Vhenard. ~~I do not believe she~~

But of what use are those if the Horadrim themselves cannot be trusted?

Neyrelle, if you are reading this, you know as well as I do that no spell or ritual could have given you what you wanted most. I think you hoped the Ritual Tome would provide you with a way to save your mother. Necromancy isn't for the dead, who are beyond our reach even when we summon them before us. It is for the living. I understand that now, and I have you to thank for it.

Kalendri's History of the Ammuit Mage Clan

This record can also be found in the Horadric Vault within the Mistral Woods. The Ammuit mage clan was one of three factions involved in the Mage Clan Wars more than two thousand years ago. The Ammuit fought alongside the Ennead Clan against the Vizjerei in a conflict that leveled cities and cost hundreds of thousands of lives before it was over. The Mage Clan Wars first erupted over the Vizjerei practice of demon summoning, which the Ammuit and Ennead Clans forbade, but which the Vizjerei pursued to their own destruction, demonstrating once again that humanity is fully capable of damning itself.

according to some estimates

The Ammuit are said to have focused their studies and schooling on the magic of illusion. Kalendri's text contains the unattributed quote, "Control the mind, and you control the world." This principle is true, so far as it goes. With sufficient enchantment, a mage can make anyone believe anything. The greater the illusion, however, the more the mind will rebel, and the harder the effort needed to maintain the spell.

Somewhat surprisingly, the Ammuit held special regard for the mages among their ranks who could control masses of people with minimal manipulation of reality. One artful practitioner is described as having toppled a tyrant with a single story that she spread among the peasantry. The trick, it seems, is to employ such subtlety that the target of an illusion is unaware of anything amiss. They are simply swept along until they dwell in a reality they believe to be theirs, when in actuality it has been carefully constructed around them. Like a fish unaware that it has been removed from its river and dropped into a pot.

Even Kalendri's book, a purported history, may be an attempt to control what we think we know about the Ammuit Clan all these many centuries later.

Soul Prisons

Centuries ago, deep in the deserts of Kehjistan, long-dead mages succeeded in trapping a powerful ghost called Ghezrim. To accomplish this, they utilized two soul prisons, and these stone altars remained intact even as the empire that surrounded them crumbled to ruin. In my lifetime, a nameless Priest of Rathma went searching for these prisons to finally destroy Ghezrim, but he perished before completing his quest. It is said the Nephalem succeeded where the Necromancer had not, first releasing Ghezrim, then slaying him.

I mention this tale here because I suspect there are many soul prisons scattered throughout Sanctuary, forgotten, waiting for some unwitting traveler to unleash the evil trapped within them. There are few who possess the knowledge needed to recognize such prisons, and fewer still with the skills and strength to defeat the prisoners. The Horadrim are uniquely suited to both tasks, and I believe it is incumbent upon them to neutralize these latent threats when and where they find them.

Yoke of Anguish

Humanity possesses few advantages against the Prime and Lesser Evils, but one would be the disunity that exists in the Burning Hells. Just as our monarchs, warlords, and priests vie for control of Sanctuary, so do demon lords scheme and wage war for control of their hellish realms. When Andariel, Maiden of Anguish, chose to ally with Diablo during the Darkening of Tristram, she enraged her fellow Lesser Evils. They chained her to an immense yoke to humiliate, punish, and bind her. This Yoke of Anguish had been fashioned and forged from Andariel's own torture racks and other implements of cruelty. Such was the suffering caused by these infernal materials that the molten metal is said to have formed itself into two faces frozen in a howling rictus of pain. Andariel broke free of her yoke during our battle with her, and we faced her unbound, in the fullness of her power.

We defeated her, narrowly, but fragments of the Yoke of Anguish remained, including the horrid faces. Though they are hateful, cursed objects, I take some comfort in them. They remind me that humans are not the only beings who turn on their kind. Demons can also be their own worst enemies.

Zakarum Statue

I have mentioned the Orbei Monastery in the Dry Steppes, laid to waste by Elias, the Zakarum monks butchered. Such a tragedy. Such a waste. I corresponded with the abbot there, and I respected him despite our religious differences. I looked forward to his letters, which always carried the faint fragrance of reddamine, an herb that grew in the monastery gardens. Elias broke the man easily with false promises and fear, and now he is dead, his house in ruin.

However, it is possible that some valuable pieces may have survived in the monastery's forbidden archive of occult relics and lore. I believe an investigation by future Horadrim would be a worthwhile endeavor, *though likely hazardous!* though the Vault may yet be protected by wards and spells. Anyone venturing there will need the key to unlock the door, a strange mechanical box of Horadric make. To open the archive, you must also recite the Secret Litanies of Zakarum in full before the monastery's guardian statues. They read as follows:

Note that the __words__ are what is required. Faith is optional.

—*From Morning, my eyes were opened and I saw the coming darkness.*
—*Through the Day, I have prepared to accept the burden of knowledge.*
—*Unto Evening, I shall keep it safe, and into the Night hereafter.*

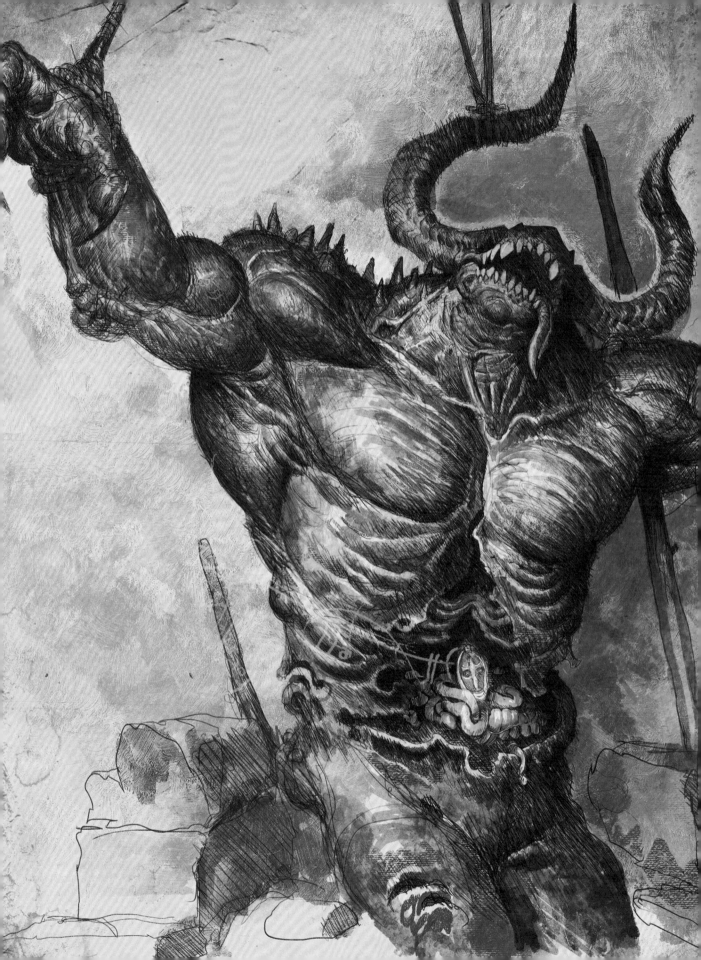

Medallion of Guulrahn

This piece of golden jewelry bears the crest of a noble clan from Guulrahn, an ancient city that was once a flourishing center of culture and trade in the Dry Steppes before Elias brought hell through the gates. Now the streets are piled with riven and half-eaten corpses. Demons, monsters, and cannibals roam freely. Families who lived there for generations are now extinct, and the dead are the fortunate ones. The streets that once smelled of spices and incense are filled with ash. The canals that once carried sweet water from the Jakha Basin are now choked with the dead.

This medallion is a ghostly emblem of the fallen, a symbol of all that was lost. It also passed through the gullet of a demon. I extracted it from the creature's steaming innards myself. The bile and acid in the demon's gut etched an ugly scar across the medallion's face. I am uncertain what being ingested by a demon does to an object like this, whether evil might have seeped into its metal. Anything seems possible.

For either of these reasons, I would avoid wearing this medallion, for it is twice cursed.

Zolaya's Whittling Knife

As Guulrahn fell, a fortunate few did manage to escape the worst depravity and destruction. Zolaya was a thief who fled to a secret cave in the cliffs above the city. From there, she might have found relative safety by traveling north into Scosglen or south into Kehjistan, but she refused to leave. Her partner and lover, a woman named Oyuun, remained trapped inside the city walls. I found her devotion admirable. It gave me joy to see the two of them finally reunited and departing that hellish place to begin a new life elsewhere.

Zolaya carried a whittling knife with her. It was a common tool, but elegantly made, with a bone handle inscribed with totems and glyphs. I wanted to ask her about its origins but refrained. I saw her put it to use in a variety of ways, and I suspect it cut purse strings and picked locks as well as it carved wood and meat. It seemed to make Zolaya's fingers nimbler and increase her dexterity, and I am quite convinced there was some magic in it. May it continue to serve her well, wherever she and Oyuun went.

Triune Shrine

Just as the Cathedral of Light builds shrines of Inarius, the cult of the Triune builds shrines of the Prime Evils. They are hewn from obsidian and other volcanic rock, arrayed with skulls and bones, and seem to glower with malevolence. The dried blood of previous sacrifices fills the cracks and fissures in the stone. The rancid soot of burnt offerings gives off an odor of sulfur and death.

A shrine is a gatehouse, and empty houses do not stay vacant for long. Eventually, someone or something will move in. To approach a Triune Shrine is to approach a gatehouse to the Burning Hells and to come into the presence of Diablo, Baal, and Mephisto. To enter Mount Civo and stop Elias from summoning Andariel, the shrines had to be appeased, and each demanded a heavy price. Should there ever be a need to visit the Triune Shrine again, the supplicant will likely be tormented with horrific visions, forced to relive past destruction visited upon Sanctuary by the Prime Evils. Be certain of your strength to endure such a trial before approaching this place.

May that day never come!

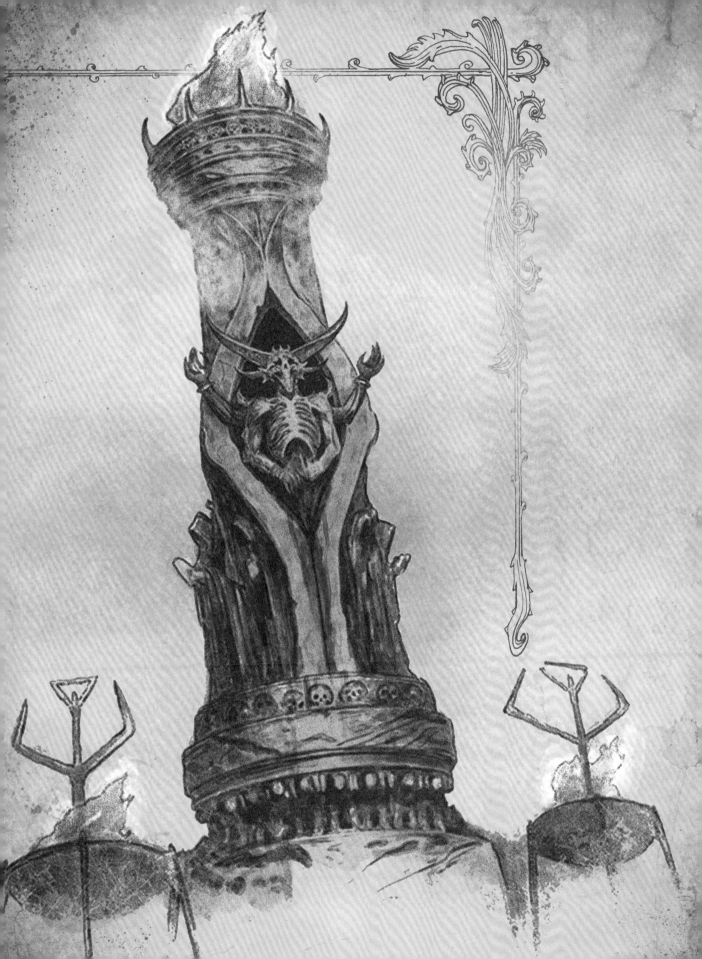

Isabella

The camels of Kehjistan are almost legendary. For centuries, they have been the lifeblood of the desert, connecting distant cities and making it possible for vital trade caravans to cross the hot dunes. Many merchants form strong bonds with their animals, achieving a wordless system of understanding and communication that even a Druid would respect.

When we encountered Meshif, he had traded the ocean for the sand and his ship for a camel named Isabella. He was as loyal to her as she was to him, and when he died, I could feel her grief and despair. With his last breath, Meshif mistook me for another Horadrim he had known: Deckard Cain. I felt no pride in his confusion, and I do not claim to be a man of the same mettle as Cain.

I couldn't find a new owner for Isabella in the time allowed us, so I made the difficult decision to set her free. She knows the desert and how to survive there, and I hope she is well. If you happen to be traveling through Kehjistan and see a camel with a yellow scarf around her neck, treat her well. And if you have any dried apricots, offer her a few. *She loves those.*

Map of Mount Civo

A volcano rises above the Dry Steppes, crowned in its own fire and ash. A maze of tunnels and chambers burrow through it, and a roiling caldera burns at its heart. It is called Mount Civo, and it is an evil place. It may have once been otherwise, but the cult that worships the Triune of Diablo, Baal, and Mephisto have long since claimed the mountain for their dark rituals. The land there is now tainted and corrupted, and that is where Elias went to summon Andariel.

There is a map of Mount Civo. It is drawn on demon hide in demon blood, and it depicts the inner passages and caverns. Who made the map is unknown, but it must have been someone intimately aware of every fork and turn. Anyone venturing into the mountain would be wise to obtain this map, or a copy of it. Without its guidance, the odds of walking back out again are quite low.

Tyrant's Pipe

As Guulrahn fell and marauders put its rulers to the sword, a new warlord rose to power. His name was Brol, and he was called Tyrant—an enormous man of great strength, ferocity, and cruelty. He encouraged the destruction of the city and delighted in the suffering of its people. He reveled in the chaos and bloodshed. When the time came to remove him from power, he fought with almost demonic fury.

The Tyrant also smoked a pipe. It was fashioned in the churchwarden style, with a long stem and a bowl carved in the shape of an opened skull. I had assumed Brol used it to smoke substances of a traditional kind. Considering his inhuman appetite and capacity for violence, I wonder if something in his blend lent him added power and rage, or if the pipe itself is a potent relic.

Then again, blaming the substance may be too easy an explanation when humanity has proven itself capable of heinous acts without any.

It may seem odd to mention an
ornamental plant in this catalogue,
so bear with me.

Exalted Topiary

Deep in the Kehjistan desert, Elias and his followers had taken
refuge at an oasis in the Exalted Palace that recalled the glory of
Caldeum as it was a thousand years ago. Fountains of crystal waters
danced in the sunlight, and the gardens bloomed with rare flowers I
have only read about. Wealthy residents and nobles gathered among
the ornamental topiaries, eating the most delectable foods and
drinking the finest wines as they waited for the world to end so a new
one could begin. They believed Lilith's lies and craved the paradise she
had promised them, and some of them even knew the price. Perhaps
they all knew.

There were no topiaries inside the Exalted Palace. There were no
fountains and no extravagant dishes. Just behind the glorious façade,
cultists tortured and sacrificed the wealthy in grisly rituals, and
demons roamed the blood-splattered corridors. Such
suffering is often the true cost of paradise. Remember
that when next you see a topiary, and then ask yourself if
Hell made the garden party possible.

Andariel's Chains

The Maiden of Anguish already mentioned has invaded Sanctuary before. It was Andariel who conquered and corrupted the Sisterhood of the Sightless Eye at the Eastgate Monastery, and Elias sought to bring her back into the world again using Taissa as the demon's host. Though initially thwarted in this, Andariel did establish a foothold in Taissa that eventually led to our confrontation with the demon. Ever since then, I have been reflecting on the nature of her bonds.

Andariel is the twin sister of Duriel, the Lord of Pain. Whereas he delights in physical agony, Andariel derives pleasure from anguish of the mind and soul. She is rightly feared for her ability to cause unbearable emotional suffering through manipulation and illusion, through stories and lies, and I believe these are her chains. Our emotions are the yoke by which she drives us, and our anguish binds us as surely as the shackles of Hell. I am also aware there are times when Andariel has nothing to do with our misery. There are times when it is not her voice in our ears, but our own thoughts that chain us to our torment. Pain is an inescapable part of life. What if suffering and anguish need not be?

Sankekur Tapestry

Mephisto completed his corruption of the Zakarum faith when one of his servants, Sankekur, became the Great Patriarch at the head of the church. He executed Mephisto's plans to corrupt even the strongest priests and most virtuous Paladin orders, and when Diablo and Baal arrived at the holy Zakarum city of Travincal, Mephisto took full possession of Sankekur's body, twisting it to reflect his horrific visage.

The tapestry depicting the death of Sankekur portrays him as a demonic monster, and the defeat of him as a mighty victory for the forces of good. These things are true. Yet we must not forget that the tapestry also depicts a tragedy, one that is not fully represented by the weaver of this hanging.

Sankekur was the Avatar of Mephisto—and a victim of the Lord of Hatred. He had a shard of Mephisto's Blue Soulstone stabbed into his hand. This was a burden few could carry without succumbing to its influence. That does not make him evil. It makes him human. We will never know for certain what manner of man he might have been.

My sympathy for Sankekur should not come as a surprise, for reasons that I've made plain. Neyrelle's ordeal has changed my feelings on many things.

BLACK SARCOPHAGUS

After the fall of the Zakarum temple city of Travincal and the defeat of Mephisto, Sankekur's twisted corpse remained dangerous and corrupted, radiating evil. The faithful who had survived the devastation determined that something needed to be done with the body to prevent its residual influence from spreading.

OF SANKEKUR

It was then that Carthas volunteered to carry the body of Sankekur to a place where it could do no harm. He had already fought heroically in the battle against the Prime Evils, and for that alone he would likely have been regarded as the greatest Paladin of his time. The sacrifice he would subsequently make ensured his name is now remembered among the finest Paladins to have ever taken their oaths.

Carthas and his companions descended deep into the crypts beneath Rakhat Keep, where they prepared a chamber as Sankekur's tomb. They lined the walls with blessed obsidian, and they also sealed the corpse in a sarcophagus of obsidian using holy wards. Yet they worried these safeguards would not be enough to contain the body's contagion of hatred. So in a noble sacrifice, they committed their souls to an eternal vigil guarding the tomb.

Gallows

꠸꠵ ꠑ꠵ ꠑꠦ ꠀꠦ ꠒꠦ ꠛꠦ ꠀꠞ

Our pursuit of Lilith eventually led to Caldeum.
Inarius and the Cathedral of Light also followed
her there, forced to battle through hordes of demons
at her command. The church met these enemies with
thorough ferocity. They showed no mercy and gave no
quarter. Their fervent cleanse of the land slew demonkind,
but also any human they believed to be in league with
the forces of Hell. They lined the road to Caldeum with
gallows, where they hung the corpses of the accused. The
smell of rot carried for miles. So thick were the clouds
of flies that they obscured the road ahead like a black
dust storm. There was nothing holy about that grim
thoroughfare. There was no sanctity in the Cathedral's
judgment, which has now fallen on the Horadrim
through Prava's Decree.

Let the image of the gallows sink into the mind
of anyone who would defy the Cathedral, for that
is the price you might be called to pay for your
opposition. Perhaps it will one day be worth it.

not just adults, but children

Arma Haereticorum

This tome emerged from Zoltun Kulle's library and contains numerous designs for legendary pieces of armor. Many of the concepts and abilities he proposes are extraordinary, unlike anything I have ever seen. It is unclear from the text whether Kulle actually used these designs to create the relics they describe. I suspect the book is more a collection of ideas he considered sound enough to write down. Nevertheless, Kulle was brilliant, so it is likely the designs contained in the Arma Haereticorum, even if theoretical, will prove successful. They may require some adjustment and refinement along the way by a talented blacksmith.

It is the need for refinement and adjustment that most concerns me. I plan to use the designs and techniques in Kulle's text for the magic I am pursuing in my journey. I am not the blacksmith my father wanted me to be. I am not the blacksmith he was. There is a blacksmith I would trust to forge what I require, however, if I can find her . . .

Rydraelm Tome

Little is known about the Rydraelm mages. Rumors accused them of engaging in deeply arcane practices. One story claimed they came from the Sharval Wilds. The high degree of secrecy maintained by their order might suggest a need to hide nefarious or forbidden magic.

Given the history of violent conflicts between mage clans, their furtiveness might simply have been a strategy for self-preservation. Either way, they are most likely extinct, according to Abd al-Hazir, who wrote, "The last time a Rydraelm mage was seen, he was being feasted upon by fallen grunts under the watchful eye of their shaman. It is safe to assume he did not survive the encounter."

Remnants of their magic could once be found in the form of tomes that allowed for the creation of their powerful mantles and robes. None of these tomes have appeared in quite some time and may have vanished along with the mages who inscribed them.

Lam Esen's Tome

Sometimes referred to as the <u>Black Book of Lam Esen</u>, this text contains many of the beliefs and magical spells practiced by followers of the Skatsim faith and represents much of what we know about this lost ancient religion. Persecution and inquisition by the Zakarum church almost succeeded in erasing the legacy of the Skatsim entirely, a history that is commonly thought to date from the earliest days of Sanctuary. At least one copy of <u>Lam Esen's Tome</u> is known to exist. It was found in the ruins of Kurast during Mephisto's occupation of that once-great city. Other copies may yet emerge.

Little is known about the author of the text. Lam Esen was accounted a sage of great wisdom and power. Adepts in Skatsimi magic are said to have used various techniques to alter their perception and awareness, granting them the ability to see distant places, and even glimpse future events. If that is the case, then Lam Esen must have seen what would become of his religion, and he compiled his tome against that day. Perhaps he wrote his book with the same urgency I feel as I write this text.

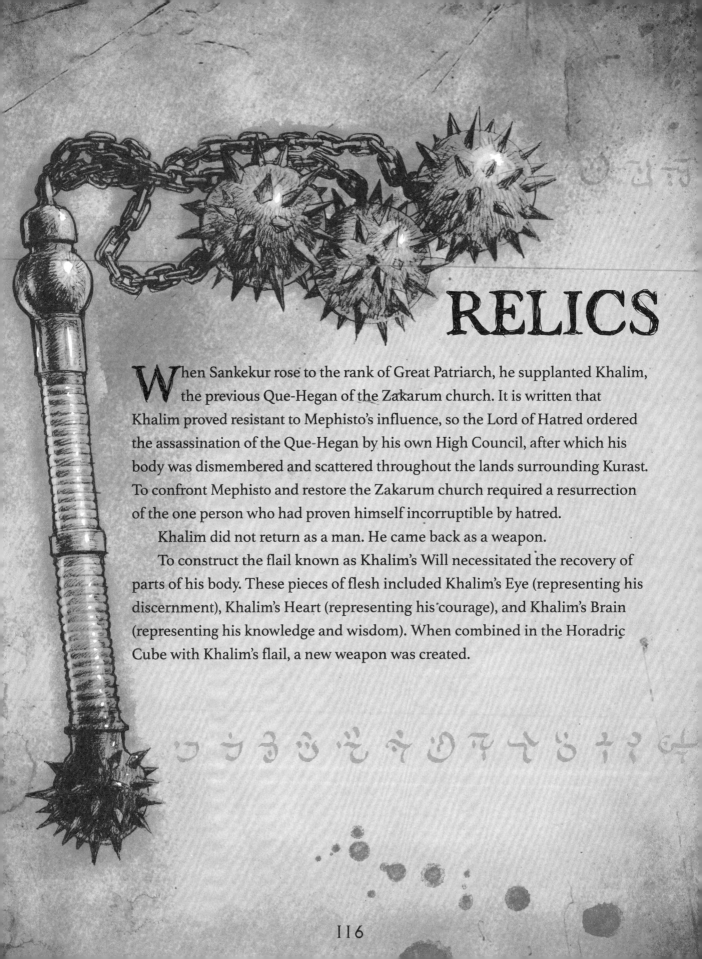

RELICS

When Sankekur rose to the rank of Great Patriarch, he supplanted Khalim, the previous Que-Hegan of the Zakarum church. It is written that Khalim proved resistant to Mephisto's influence, so the Lord of Hatred ordered the assassination of the Que-Hegan by his own High Council, after which his body was dismembered and scattered throughout the lands surrounding Kurast. To confront Mephisto and restore the Zakarum church required a resurrection of the one person who had proven himself incorruptible by hatred.

Khalim did not return as a man. He came back as a weapon.

To construct the flail known as Khalim's Will necessitated the recovery of parts of his body. These pieces of flesh included Khalim's Eye (representing his discernment), Khalim's Heart (representing his courage), and Khalim's Brain (representing his knowledge and wisdom). When combined in the Horadric Cube with Khalim's flail, a new weapon was created.

OF KHALIM

Khalim's Will had the power to destroy the Compelling Orb and open the way to the Durance of Hate. It was supposedly destroyed by the release of arcane energies that resulted. I have heard rumors of a similar flail, the Que-Hegan's Will, that appeared some time ago in the Halls of Agony below the manor of the mad king, Leoric. I will leave it to others to determine whether these two weapons might somehow be one and the same, for I believe it is possible.

It is also possible that the name of Khalim is now a weapon unto itself, capable of striking a blow against the demons who quake at the memory of his strength. To invoke the legacy of a hero of legend is to assume a shade of their mantle and charge once more with them into battle.

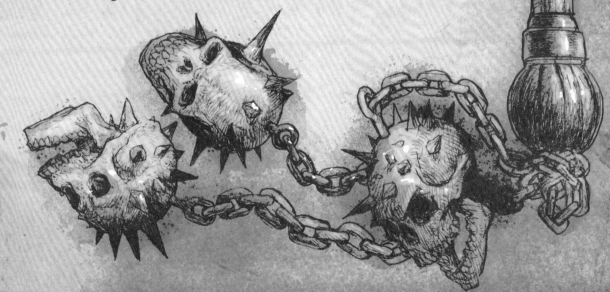

Compelling Orb

I have thus far been quite critical of the Zakarum church. I feel justified in everything I have written. However, in the interest of fairness, there is one relic that speaks somewhat in their defense.

The Compelling Orb stood on a black pedestal, flanked by curved blades of bone arranged as if in mockery of angelic wings. The globe emitted a commanding magical field that allowed the High Council of Zakarum to exert control over their followers. Mephisto had this relic placed in the ruined temple city of Travincal, where it also guarded the entrance to his lair in the Durance of Hate.

The mere existence of this relic implies that Mephisto and the High Council could not have maintained obedience among their followers without it. This in turn suggests that some of the Zakarum priests, if not many of them, would have rebelled against the demonic presence at the heart of their church. The Compelling Orb demonstrates that Mephisto had not taken over the faith so completely that he could manipulate it without the aid of powerful magic. I take a measure of reassurance from that.

a slight measure

Ashes of Ku Y'leh

Throughout history, many scholars, priests, and mages have obsessed over the mystery of what lies beyond death. Some have used dark rituals that even Necromancers will avoid glimpsing the afterlife. Fear of death has driven others to prolong their lives through unnatural means that always come at a price. ————————————

One man well known for his interest in mortality was the sage Ku Y'leh. His age isn't given in any sources. It is believed that he found the means to extend his life considerably through elixirs and potions. True immortality eluded him, however.

Upon his death, his ashes were placed inside a golden statue shaped like one of the songbirds found around Kurast. Many years later, this relic ended up in the collection of Meshif, and it ultimately proved valuable when the ashes were extracted and used in a new potion of life and health. In this way, Ku Y'leh did live on past his death—just not in the way he intended. The same will be true of us when our bodies become food for worms and carrion crows. We are all but links in a chain of death and immortality.

Tinue's bargain with the swamp comes to mind.

Wirt's Bell

There was once a lad from Old Tristram whose name is now surprisingly well known for someone of his common background. Wirt began his life like any child. That all changed when demons tore him from his mother's arms and carried him down into the crypts below the Tristram Cathedral. I can well imagine what the boy must have seen and endured there, and it pains me to think of such things happening to one so young. Though he was rescued, the torture inflicted upon him ruined his leg, which had to be amputated. He walked with a wooden peg afterward and was said to be altered in temperament, becoming hardened, angry, and bitter. He took up trading stolen wares in the single-minded pursuit of gold, and even though he died long ago, relics connected to him keep turning up, along with his name and his tragic tale.

Wirt's Bell is an ordinary tarnished cowbell, and of itself does little beyond ringing in the way that would be expected. However, when it is combined with several other relics, an object is created known as the Staff of Herding, which supposedly opens a portal in the ground that leads to another plane of surreal vibrance and violence. Or so I am told. I am skeptical of these claims. The description of this whimsical realm is suspiciously akin to hallucinations produced by various fungi that happen to grow near New Tristram.

Opium Pipe

ᚠᚾᚲᚾᛗᚲᛗᚾᚠ

Though we left Meshif's body behind in the desert, I took his pipe with me. It is a delicate relic, long and slender, with an ornate bowl at the end. It appears to be made of jade, carved so thinly that light passes through it, rippling as through seawater. It still smells faintly of the drug Meshif smoked, for which I cannot fault him. He came from Kurast. He watched his homeland's destruction by Mephisto, and his grief must have been a heavy burden. Despite the tragedies Meshif had suffered, he offered aid and friendship to the Horadrim when needed, ultimately at the cost of his life. That is why I want to preserve his pipe and incorporate it into my work with this book. It is not imbued with magic, though it is a potent symbol of hope and courage. In this way, I can honor Meshif's sacrifice.

I now have the relic I came to retrieve from Caldeum. It is an arrow known as the Breath of Philios. I was pleased to find it in the repository where Horadric records indicated it would be. I only hope that it will be an adequate gift to satisfy the Askari. From here I travel south to what remains of Kurast, where I hope to hire a ship.

Neyrelle was here. My fears are confirmed.

Kurast is not the safest of ports. It hasn't fully recovered from the devastation caused by Mephisto's ascendance, but it has achieved stability. Yet when I arrived, I found it in chaos. Violence has erupted like a plague. Old rivalries have been renewed. Neighbors slaughter neighbors over trivial slights. Hatred reins.

The same fate befell the village of Yelesna after Neyrelle passed through it. Fortunately, Kurast is far enough south it might be spared the brutal retribution of the Knights Penitent. I must do what I can to help these people.

Order is gradually being restored. The fever of hatred has broken. From my inquiries, I have gathered that Neyrelle was only here for a short time, barely a day. I wonder if she is even aware of what she leaves in her wake.

A ship arrived today. I went to see its captain about passage across the Twin Seas, and I was surprised when he seemed to recognize me. He said his previous passenger had described me well ("an old man whose face has forgotten how to smile"). Then he gave me a letter from her.

Lorath,

I should not have come to Kurast. This was Mephisto's domain. Almost as soon as I arrived, his voice grew louder, more insistent. The Lord of Hatred laughs at humanity's insignificance. He mocks my weakness. He shows me the ruin that is to come. Sanctuary devoured. I fear the raging storm inside my head will drive me mad.

Before coming here, I thought I was learning to ignore his voice and see through his visions. But I should have anticipated this. I was a fool. No doubt you would have tried to warn me if you were here. Perhaps I would have listened.

I am leaving Kurast as quickly as I can, and I will not repeat this mistake. I must seek some way of silencing the Lord of Hatred. I must find a way to keep my sanity. But don't worry, old man. I am not lost yet.

Neyrelle

I have secured passage on the ship that carried Neyrelle. After some argument and an absurd amount of gold, I managed to convince the captain to take a detour south to the Skovos Isles before the crossing to Aranoch.

Seasick.

I hate ships.

The seas closer to the Skovos Isles have calmed, and they are as lovely as the stories claim. The turquoise waters sparkle like faceted jewels. The sandy beaches and island cliffs are white as clouds and capped in lush green canopies. The ship captain says we should reach the capital city of Temis before nightfall.

That did not go as planned. I expect the captain will ask for more gold. I will pay it. We are probably lucky to be alive.

Before we reached Temis, several Askari ships charged across the waves toward us. They moved with the speed and cold elegance of sharks. They forced us aground in a small bay, far from any city or village, though I did catch a glimpse of tiled roofs and marble colonnades through the trees. They demanded our names and did not respond well when I announced myself as Horadrim. I had hoped to offer the Breath of Philios in exchange for information about the delegation Tyrael had sent. I never got the chance. They ordered us to leave their waters, and there was no negotiating with their spears and bows. We sailed for Lut Gholein.

I do not believe there is any sight in all of Sanctuary more beautiful than the sands of Aranoch turned to silver by the light of the full moon on a clear night.

This sentiment is attributed to the Horadrim Shanar, who passed a lonely vigil over Tyrael's sword, El'druin, upon finding it in the desert of Aranoch after it fell with him from the High Heavens.

HORADRIC

The Horadrim were well known for their mechanical arts and ingenious devices. Of those relics that survive today, the alchemical cubes are perhaps the most mysterious. Like a witch's cauldron, they transmute components and ingredients into new creations. At times, these Horadric Cubes almost seem to possess a unique form of consciousness, as if they operate by their own internal rules of logic for transformation. Records of their construction are scarce. It seems that even the Horadrim engineers who designed them struggled to understand their creations. The cubes were to them then as they are to us now, like the chrysalis of a moth in which mysterious processes take place without our ability to see or direct them.

The cubes offer no assistance to those seeking to use them. Recipes must be discovered through trial and error, and it would not surprise me to learn that we have barely documented a fraction of what the cubes can produce. The combinations and permutations of materials and ingredients are seemingly infinite.

A relic known simply as the Horadric Cube was one such device, but it was preceded by another, Kanai's Cube, named for the man appointed to guard it. Kanai's Cube so frightened the Horadrim that they hid it away shortly after its completion. We do not know precisely what fears caused them to take such drastic action. I have no doubt it was a wise course. Those same artificers believed the Horadric Cube to be free of the flaws that marred the functioning of Kanai's Cube, and I trust they were right in this also.

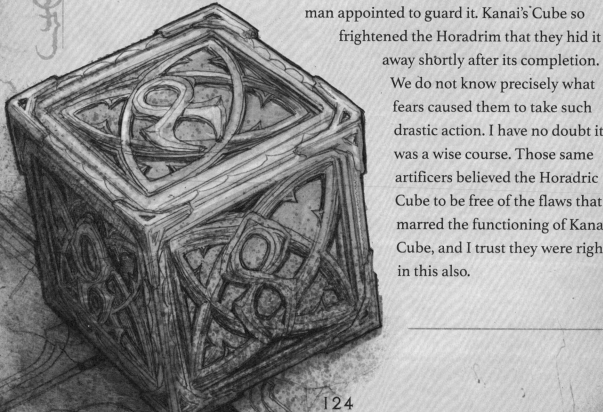

CUBE & STAFF

After the Horadrim locked Tal Rasha in his tomb, they had to decide what to do with the key. The Horadric Staff had significant power on its own. Its ability to reopen Baal's prison made it an extremely dangerous relic. To prevent the forces of evil from obtaining the staff, the Horadrim separated it into two pieces that could only be reunited by using the Horadric Cube. This seemed a wise plan, and they used that same strategy many times through the centuries, for many relics.

The first piece was named the Staff of Kings. Descriptions of it portray it as golden or bronze, with the carving of a snake coiling upward around the central shaft and a jewel in the serpent's mouth at the top. It eventually found its way into the den of Coldworm the Burrower, an enormous sand maggot queen.

The second piece, the Viper Amulet, was cast in the shape of a cobra's flared cowl, with fine enamel inlay and ruby jewels. It was unearthed from the broken altar of the Claw Viper Temple, deep in the valley of Aranoch's snakemen.

Deckard Cain personally oversaw the reunion of these two relics to remake the Horadric Staff, a necessary step in preventing the return of the Prime Evils to power. The strategy of separation devised by those earlier Horadrim had succeeded in keeping Tal Rasha's tomb sealed for more than two hundred and fifty years. As with Soulstones, however, no prison can last forever. So long as a key exists, its door can be opened.

Horadric Scroll

This scroll contained the knowledge needed to restore the Horadric Staff and unlock Tal Rasha's tomb, information that might have proven dangerous had it come to be known by those who serve the Prime Evils. The only safeguard against this happening seems to have been the coded Horadric Runes in which the document was written. It was fortunate, then, that Deckard Cain happened to be present when needed to translate it. He was the last Horadrim living at that time. Events would have unfolded very differently, perhaps cataclysmically, if no Horadrim had been left to read it.

I am taking different precautions and using different protections with this book I am writing. It is obviously not coded in Horadric runes.

Or at least no Horadrim as knowledgeable as Cain!

Morbed's Lantern

Morbed the Rogue is a fascinating folk figure. As a boy in Westmarch, I grew up listening to tales of his exploits whispered in taverns on dark nights. Everyone knows someone who knows someone who claims to have encountered Morbed on the road. There are so many versions of so many stories they cannot all be true, and yet I am convinced the man truly existed.

or exists

His story begins with a vagabond who had been robbing the ancient tombs and catacombs of Westmarch. The king resolved to stop these raids and sent a company to hunt down the thief and recover the stolen relics. Morbed was a member of this party. When the group tracked their quarry to a small island, the vagabond revealed himself as a powerful sorcerer. He summoned a demon, and suddenly the fight seemed utterly hopeless. Morbed fled in terror, abandoning his companions to their deaths, and soon after found a mysterious lantern chained to his wrist by a jailer's manacle. This relic contained the spirits of the comrades he had betrayed, and Morbed was cursed to wear it until he had atoned for his cowardice.

Now he is said to wander the land, aiding those in need. I have heard tales of him fighting off bandits or defending a shepherd's flock from attacking beasts. One account even had him repairing the broken axle of a wagon. But all Morbed stories begin and end the same: with the rattle of chains and a lantern bobbing in the night, shining with a ghostly light.

Broken Promises

This ring once had a different name and a different appearance. It was originally a gift between lovers to represent their bond, with twin diamonds sharing a setting, sitting side by side. Their love was not to last, and when their union ended in betrayal and heartbreak, one of the lovers had this relic remade. The diamonds now sit apart, almost on opposite sides of the ring, and archaic glyphs have been inscribed between them, telling a tale of sorrow and broken trust. It is said that donning this ring brings a cloud of melancholy down upon the wearer in exchange for feats and skills requiring fewer resources to perform.

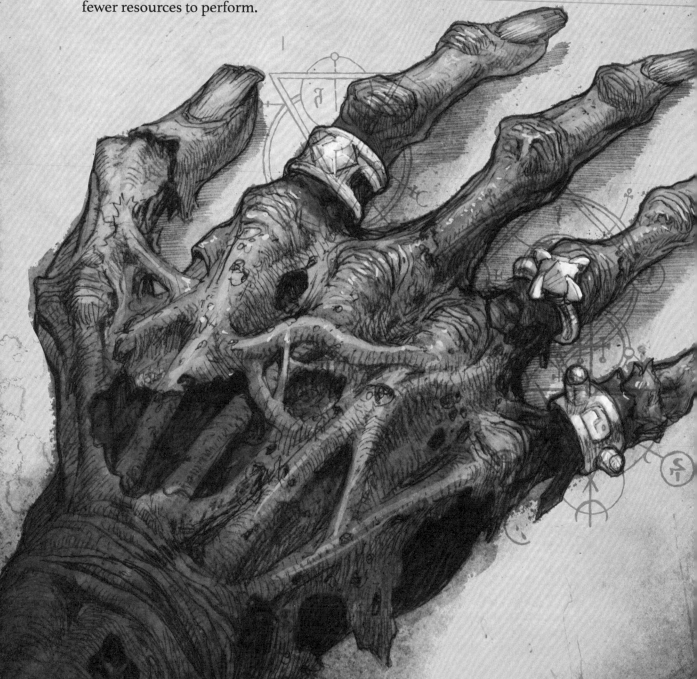

Eternal Union

This is a Zakarum Crusader ring. As such, I have little interest in it. Nevertheless, I will share what knowledge I have in case it proves helpful in ways I don't fully appreciate.

Crusaders have the ability to summon spectral Avatars of the Order into battle at their side. I have always assumed these entities are the spirits of other fallen Crusaders; then again, that would be uncomfortably similar to Necromancer magic for a follower of Zakarum. Regardless, the Eternal Union ring creates a much stronger connection between the summoner and the Avatars called to their aid. With the aid of this ring, a Crusader's spectral allies will persist on our plane twice or thrice as long as they would otherwise.

Litany of the Undaunted
& the Wailing Host

Some relics share their power across several objects. These sets may have been forged together, or they may have been worn by the same legendary figure, uniting them in purpose. Relics from such collections often have unique properties when used individually. When they are united and worn as a whole, they often grant the wearer considerable advantages through a kind of synergy.

The Legacy of Nightmares is a set of only two rings, very similar in appearance, each with a single gemstone in a silver setting. The first is the Litany of the Undaunted, so named for the impossibly miniscule writing inscribed across its surface. Legend claims it bears the names of all those who gave their lives fighting against the Burning Hells, and that these heroes lend their strength to the one who wears the ring. Its companion is called the Wailing Host, and contains the fury of a thousand screaming souls, perhaps belonging to those whose names appear on the Litany of the Undaunted. Together, these rings allow the wearer to tap a wellspring of ancient power, such that they match the might of seven or even a hundred warriors.

Kymbo's Gold

Abd al-Kymbo was a merchant who ran a caravan between Aranoch and the Western Kingdoms, braving the dangers of the desert in pursuit of wealth. He was an observant man, and he learned how to read the signs of danger. In lonely places where other traders fell victim to bandits, demons, and beasts, al-Kymbo crossed safely through. He shook his head as he passed the remains of less fortunate caravans, stopping to gather the gold and treasure that had been scattered and left among the wreckage. Then one day, he thought of a way his salvaging could reward him twofold.

He commissioned the creation of an enchanted amulet. Now known as Kymbo's Gold, it was a heavy piece of jewelry, shaped like a hand grasping a coin. Abd al-Kymbo believed that health and wealth should be synonymous, so he designed this relic to grant him health for each gold coin he found. Within a few years, he tired of the road and decided to retire in luxury. His amulet will now aid any wearer in the ways it aided him.

Radament's Hourglass

Time is slippery in the sense that we are all certain we know what it is until we try to define it. Even though we weigh it with the sands of an hourglass and measure it by the height of a burning candle or the movement of a shadow across a sundial, we are not defining time. We are merely asking something else to represent it. We do this often, as when we speak of time in the metaphorical language of gold. We spend it. We waste it. We save it. We lose it. But what if we could think of time in a different way, using different metaphors? What if we sailed time? What if we breathed it?

I do not know if Radament created this hourglass, but it was associated with him while he lived, long before his return as one of the fallen Undead. It does have some features of Horadric craftsmanship. I have read no account of its creation in any Horadric tome, only its location. The metal is highly refined, with the hardness of platinum and the fluid luster of quicksilver, cast in the shape of a snake that coils around the crystal vessel at the center. Within the glass, the shimmering sands of Aranoch swirl as if somehow perpetually windblown inside their shell, never settling at one end or the other, regardless of the position of the hourglass.

This flaw would seem to make this relic rather useless as a practical measure of time's passage. Only if we think of time in the usual, practical way. The power of this artifact is to slow time for the user, such that moments seem to expand to the capacity of hours. As if time inside the glass is something different from time outside it. That is why I claimed this relic from a tomb outside Lut Gholein. The ritual I will perform on this book must last outside of time.

Have joined a caravan heading west. The caravan driver seems competent. He recognized me as Horadrim a few days out from Lut Gholein. Didn't even try to hide his displeasure at it. I think if he had realized who I was before we left, he would have declined to take me. He claims another driver he knew, called Warriv, once helped Deckard Cain, and this led to Warriv being cursed. I assured him Cain cursed no one, and neither would I. He did not seem satisfied, but thankfully he dropped the matter.

The caravan driver must want to be rid of me. We are pushing hard, making good time. I'm sure the camels resent us. Before long, we'll cross the mountains into Khanduras. From there, I travel to New Tristram.

Then, after all these years, I am going home.

Westmarch. The place of my birth. I have seldom been back since Malthael's Reapers tore through its people, almost annihilating the city. Even after so many years, the devastation remains evident. The streets are too quiet. The market squares are a somber shadow of the bustling hives of commerce I knew in my youth. Many houses and buildings sit empty, boarded up, given over to vermin and rot.

There are faint signs of renewal, however, like a stubborn weed I passed bearing little white flowers. It was reaching out of a crack in the cobblestones, and at another time, someone would have pulled it out. Yet what is a weed but a flower out of place? Somehow, the sight of it almost made me weep, and I left it to grow.

My greatest relief is found in the absence of any sign that Neyrelle has been here. I see no evidence of Mephisto's influence.

It is now time to see what is left of my father's smithy . . .

"*Rakanishu!*"

The Fallen encountered in Khanduras can still be heard spouting the name of a powerful chieftain as a war cry when they charge into battle, even though that chieftain is long dead. In this way, it seems that demons are not dissimilar from humans, for we also hold to the names of old heroes and champions. I have no doubt the Cathedral of Light will go on shouting the name of Inarius.

"We have all heard
the tales associated
with Tristram. The very
mention of its name brings
to mind images of undead
monstrosities, demonic possession,
monarchy driven to lunacy, and,
of course, the greatest legend of
all: the Lord of Terror unleashed.
Although many now claim that
a peculiar mold upon the bread
or perhaps a fouling of the water
drove the populace mad with
visions, I have seen too much
in my varied travels to dismiss
such stories out of hand."

—Abd al-Hazir

As unlikely as it might seem, there are those who dismiss as mere stories what we Horadrim have seen and fought firsthand. Such willful ignorance angers me until I remember that most people would be defenseless against even the lowest Fallen demon. It is much easier to blame such horrors on hallucinations than to believe the Burning Hells might literally open beneath your feet. As I write this, I realize I am guilty of doing the same thing in these very pages regarding Wirt's Bell. I suppose we all have limits to what we can accept and believe.

Arma Mortis

As Malthael abandoned his Aspect of Wisdom and took up the Aspect of Death, he began experimenting with the composition and uses of human souls, a process that killed the humans he tortured. One of his Reapers wrote down the results of this research in a tome—the Arma Mortis, otherwise known as the Weapon of Death. Its pages describe the methods of forging relics with human souls to make weapons of great power and destructiveness. This alone would make the Arma Mortis an extremely dangerous text.

I see something else in it that may cause me even greater alarm. It was humanity's demonic heritage, their "mote of pure darkness," that made their souls so potent in the creation of weapons. Malthael and his angels therefore made use of that which they most abhor, a hypocrisy of the highest heavenly order. They would have refused any demon blade made in the Hellforge, yet they embraced the weapons they made with half-demon souls. Perhaps they believed that their righteous purpose turned the evil into good, when it only resulted in the corruption of their heavenly weapons. Malthael and the Arma Mortis teach us that to use evil in the fight against evil only makes us evil ourselves.

I tried pointing this out to Donan on more than one occasion. His faith in the angels remained unshakable, until Inarius broke it.

Myriam's Mirror

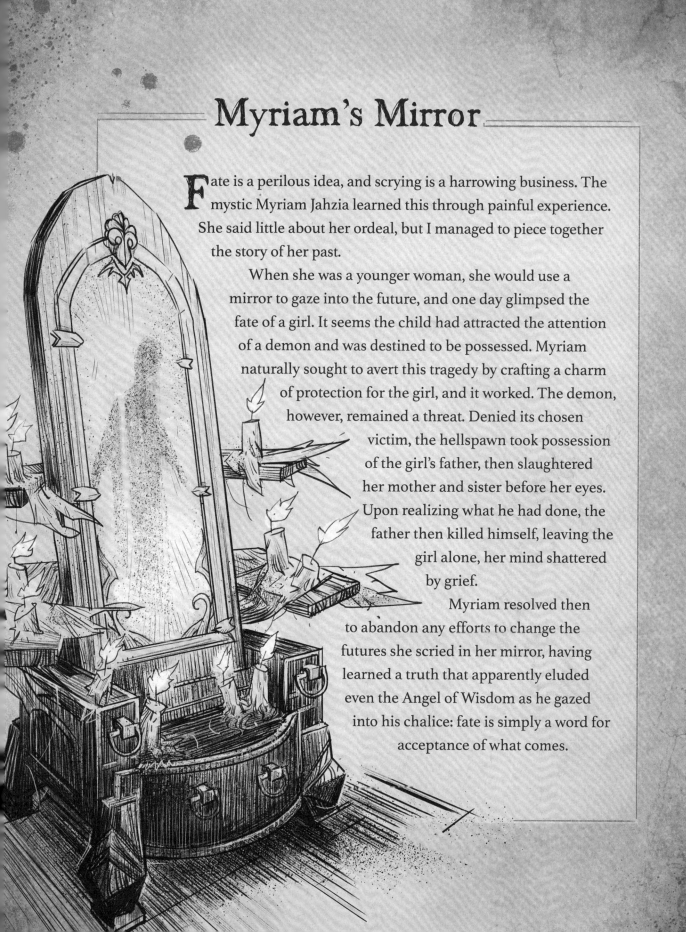

Fate is a perilous idea, and scrying is a harrowing business. The mystic Myriam Jahzia learned this through painful experience. She said little about her ordeal, but I managed to piece together the story of her past.

When she was a younger woman, she would use a mirror to gaze into the future, and one day glimpsed the fate of a girl. It seems the child had attracted the attention of a demon and was destined to be possessed. Myriam naturally sought to avert this tragedy by crafting a charm of protection for the girl, and it worked. The demon, however, remained a threat. Denied its chosen victim, the hellspawn took possession of the girl's father, then slaughtered her mother and sister before her eyes. Upon realizing what he had done, the father then killed himself, leaving the girl alone, her mind shattered by grief.

Myriam resolved then to abandon any efforts to change the futures she scried in her mirror, having learned a truth that apparently eluded even the Angel of Wisdom as he gazed into his chalice: fate is simply a word for acceptance of what comes.

Jewel of Dirgest

I have never heard of or read any accounts that call this ruby relic a Soulstone, and yet it is said to have imprisoned a demon. The story's roots are found on the island of Xiansai in the gods they worship there. The jewel was originally a gift from a legendary thief to the goddess of the second moon. It was later used to confine her jealous husband, the demon Dirgest. The Nephalem went in search of this ruby with the jeweler Covetous Shen, only to find that it had been shattered and Dirgest had escaped. I have since heard a rumor that the shards of the ruby ended up reset in a new piece of jewelry called Shen's Remorse, though this is unverified.

inevitably

 I am not sure what more to say about this relic or its story, other than to point out that even the myths and folktales from the distant island of Xiansai seem to understand the folly and danger inherent in Soulstones.

Shen's Tools

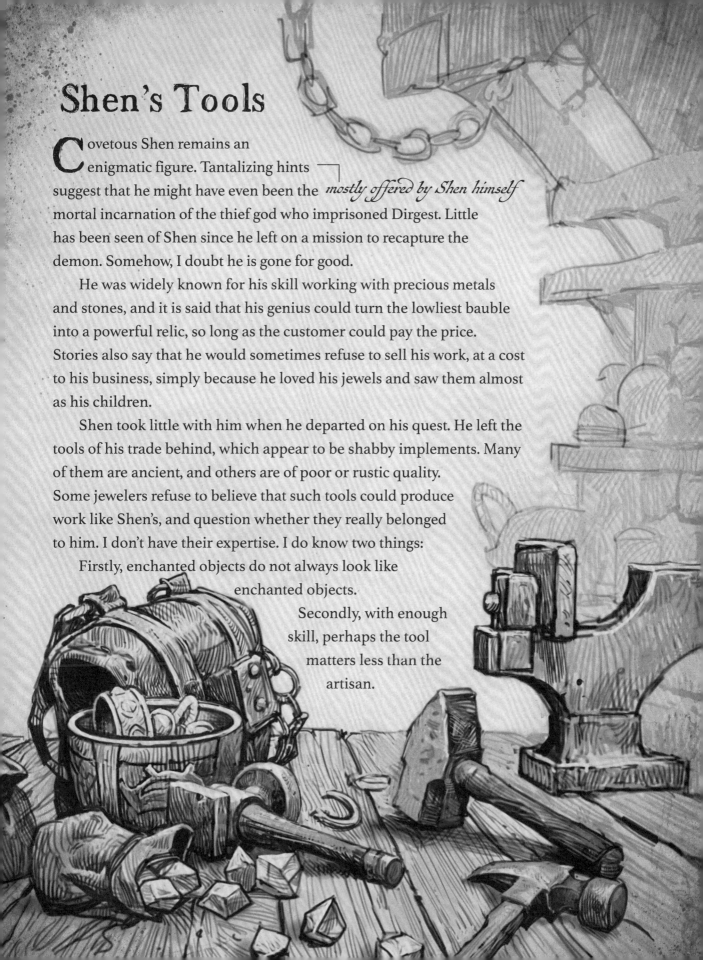

Covetous Shen remains an enigmatic figure. Tantalizing hints suggest that he might have even been the *mostly offered by Shen himself* mortal incarnation of the thief god who imprisoned Dirgest. Little has been seen of Shen since he left on a mission to recapture the demon. Somehow, I doubt he is gone for good.

He was widely known for his skill working with precious metals and stones, and it is said that his genius could turn the lowliest bauble into a powerful relic, so long as the customer could pay the price. Stories also say that he would sometimes refuse to sell his work, at a cost to his business, simply because he loved his jewels and saw them almost as his children.

Shen took little with him when he departed on his quest. He left the tools of his trade behind, which appear to be shabby implements. Many of them are ancient, and others are of poor or rustic quality. Some jewelers refuse to believe that such tools could produce work like Shen's, and question whether they really belonged to him. I don't have their expertise. I do know two things:

Firstly, enchanted objects do not always look like enchanted objects.

Secondly, with enough skill, perhaps the tool matters less than the artisan.

Cursed Crucible

This vessel emerged from the Eastgate Monastery, brought there from the Hellforge by a demon known as the Smith. After Andariel's defeat, the Cursed Crucible was discarded when the Sisterhood of the Sightless Eye rid their house of all demonic remnants. I am certain they would have been more careful had they understood the curse that is upon it. The crucible eventually turns its owner into a monster, which is what happened to a man named Gavin when he and Shen went looking for the relic in the aqueducts from the Dahlgur Oasis.

Despite this, Shen did not seem overly concerned about the curse for himself and even put the crucible to use in crafting his jewelry.

Adds support to the idea that Shen was or is more than he seems?

Scoundrel's Tokens

Some relics are highly idiosyncratic and relative in their worth. Some may even call them superstitious and worthless. A lucky pair of loaded dice or a brooch would do little to nothing for a Horadrim. Those same tokens could prove indispensably powerful when carried by a thief to whom the objects have meaning.

Few scoundrels want their names known. Lyndon was one thief who aided in the battle against the forces of the Burning Hells in ways significant enough for him to be considered a hero. As Lyndon traveled with the Nephalem, he carried powerful tokens of his former criminal life, and superstition or not, the benefits of these objects were undeniable. Perhaps such relics possess true magical power. Perhaps they simply inspire the one who carries them to find hidden strength and skills inside themselves. Either way, they should not be discounted simply because they only have meaning to a few.

unless that Horadrim also happened to be a thief

Templar Relics

Templars carry relics unique to their training and their faith. Holy tomes and texts provide them with mantras and teachings to contemplate that hone their focus in battle to a sword point. Shards of sacred blades carried by previous Templars grant them access to holy lineage and authority, while chalices and vessels of holy water keep them pure. To those outside the Templar faith, these relics would offer nothing, and might even offend those who hold the Zakarum church in low regard. As with the Scoundrel's Tokens, it is the Templar's own faith that matters.

One member of the Templar Order, a man named Kormac, came to follow the Nephalem and left the cruel practices of his order behind. When he still had faith, his relics granted him divine power. I wonder if he ever considered that his power may have come from inside him all along . . .

Enchantress Focuses

The third and final hero to follow the Nephalem was an enchantress named Eirena, who had survived since the time of the Mage Clan Wars in magical slumber. To better channel and control arcane energy, she and other wielders of magic use Focuses. A suitable relic for this purpose might be a mirror, a demon's eye, an amulet, or a crucible, so long as it helps the mage to concentrate and access the source of their power.

Hierophant's Seal

also known as Krede's Flame

There once existed a ring of legend known as the Hierophant's Seal. It was made by an early follower of Akarat before power turned the Zakarum faith to zealotry. Envision a simple gold band with an engraved cameo of glyphs, with the ability to grant tremendous powers of life and healing while also increasing the skill to harm and destroy demons. The lore and name associated with this ring called on the wearer to guide and protect humanity, like how a shepherd guards a flock of sheep. It was a blessed ring with a noble purpose, until it fell into the hands of Duke Krede.

On the outskirts of Caldeum, Krede held warrior tournaments in an arena of fire for his entertainment and enrichment. Audiences paid to watch the brutal spectacle that claimed the lives of many aspiring champions. The largest crowds gathered when Krede himself joined the fray. He always won, even against fiercer, stronger foes, until the day a frozen-imbued demon invaded his manor and slew him.

Only later was it discovered that he had remade the Hierophant's Seal into a new ring with new properties. Although it looked the same as before, it now used the fire of Krede's arena to increase his fury, giving him a significant advantage. Thereafter, the ring was called Krede's Flame.

It must be noted that his changes to the ring for the sake of his arena left him vulnerable. If he had left the Hierophant's Seal as it was, he could have defeated the demon who killed him.

Necromancer Totem

The Priests of Rathma use a variety of relics as phylacteries. Perhaps the most profane and grisly are the totems they carry. To wear the preserved head or skull of a dead thing strapped to a belt is to break powerful taboos. The sight of a Necromancer can silence a crowded tavern, and mobs will part before them. Their totems mark them as ones who know less fear, and fewer limitations. They serve the Balance, the endless cycle of life and death, decay and renewal, and that requires them to stand apart. To be a Priest of Rathma is therefore to walk a lonely, desolate road.

The image of the Necromancer Totem has a different effect on me now, calling to mind a certain tree that waits for my head.

Ms. Madeleine

There is a type of dark ritual found in many witchcraft traditions across Sanctuary, from Hawezar to Torajan to the Sharval Wilds. Though regional variations exist, the spells all involve the creation of an effigy that is meant to represent the target of the magic by proxy. If the ritual is successful, whatever is done to the doll is supposed to be visited upon the victim of the curse.

A doll known as Ms. Madeleine appears to have begun its existence through this type of magic. She is a rather hideous little thing, merely a lumpen sack with stubby appendages, a bulbous head, and rudimentary features. She still bears the signs of her physical torture, having been impaled by bone needles and suffered the loss of a button eye, injuries her human counterpart likely did not survive. In most instances, that would be the end of the ritual. Perhaps some other magic is at work in Ms. Madeleine.

She is animate. Enthusiastically, cheerfully animate, though no one save her creator could say with what kind of soul. Others may be unsettled by her. I find her strangely comforting. If an entity like Ms. Madeleine, born of pain and hatred, can be what she was and is and still be joyful, perhaps there is hope for the rest of us too.

Horadric Malus

The construction of powerful weapons and armor may require powerful tools. The ancient Horadrim possessed a smithing hammer, the Horadric Malus, which they used in the forging of many legendary creations. Cain once speculated that the Malus could trace its earliest origins to the Sin War before Tyrael had formed the Horadric Order. While we likely cannot know that for certain, we do know that the hammer was eventually entrusted to the Sisterhood of the Sightless Eye.

When Andariel conquered the Eastgate Monastery, the Horadric Malus fell into the hands of a demon known only as the Smith. It was eventually retrieved and restored to Charsi, the talented blacksmith of the Sisterhood. But during its separation from her, it was used at least for a time to forge weapons for the minions of the Burning Hells, and I suspect it worked as well in the service to evil as it did in the service of good. That is the nature of most tools. They are defined by how we use them.

I hope she still possesses it.

Leoric's Signet

When Diablo darkened Tristram, he did so by slowly corrupting Leoric, the king of Khanduras, who was known as both good and wise in his youth. His later journals are harrowing to read. The madness overtaking his mind becomes evident page by page, as does his confusion, doubt, and fear, and I cannot help but wish for some way to reach through the text to warn him. I know that even if that were possible, it would change nothing. If not Leoric, the Lord of Terror would have simply chosen someone else. No warning could change the fact that Diablo's prison could not hold him.

Some might believe that Leoric's Signet and other relics are cursed, and that is possible. I am not convinced of it, though. Leoric was not always the Skeleton King or the Mad King of Tristram. Careful study and thorough identification would be recommended and prudent before using any relics, especially those belonging to fallen monarchs.

Lazarus's Grimoire

The Prime Evils found the perfect servants in the Zakarum church, which had strayed far from the spirit of Akarat's original teachings. The priests had become accustomed to strict, blind obedience, to the point that <u>who</u> they served seemed less important than whether they did as the church and Que-Hegan commanded.

Although Lazarus may have once been a righteous man, by the time he came to Tristram, he knowingly and fully served the Prime Evils. The writings in his grimoire from that time chill the blood and turn the stomach, and because of this I believe his relics are more likely to be cursed than those belonging to Leoric. Be wary of his tomes, and others like them. The words they contain come from the mouth of the Burning Hells as much as from their author's hands, and demons know that books are made to last for a very long time. They know that scholars and mages trust their ancient texts implicitly and that books are a very effective way to get inside a person's mind.

just as I am doing now

ϟ ƛ ⅄ ℧ ℺ ⚲

Token of Absolution

I have never attempted to create a Token of Absolution, yet I have read about them. They offer a very narrow and dangerous path to those who wish to clear their minds and bodies of entrenched habits and less desired skills. They allow for a new beginning while retaining wisdom and experience, a rare gift indeed. If you would seek to create one of these tokens, you will need the Horadric Cube. Note the ingredients placed within it will be extremely difficult and dangerous to acquire. To receive absolution, you must prove yourself <u>worthy</u> of it by confronting not only two Lesser Evils, Andariel and Duriel, but also the three Prime Evils. It is the essences of these five demons that you must obtain and place in the Horadric Cube.

Let us put aside the possibility that all five could be found in Sanctuary at the same time. If you somehow battle them and survive, I will humbly suggest that you perhaps need less absolution than you think. In fact, the entire notion of the Token of Absolution leads me to wonder if the Horadric Cube possesses a sense of humor.

Which I pray will never occur again!

Jar of Souls

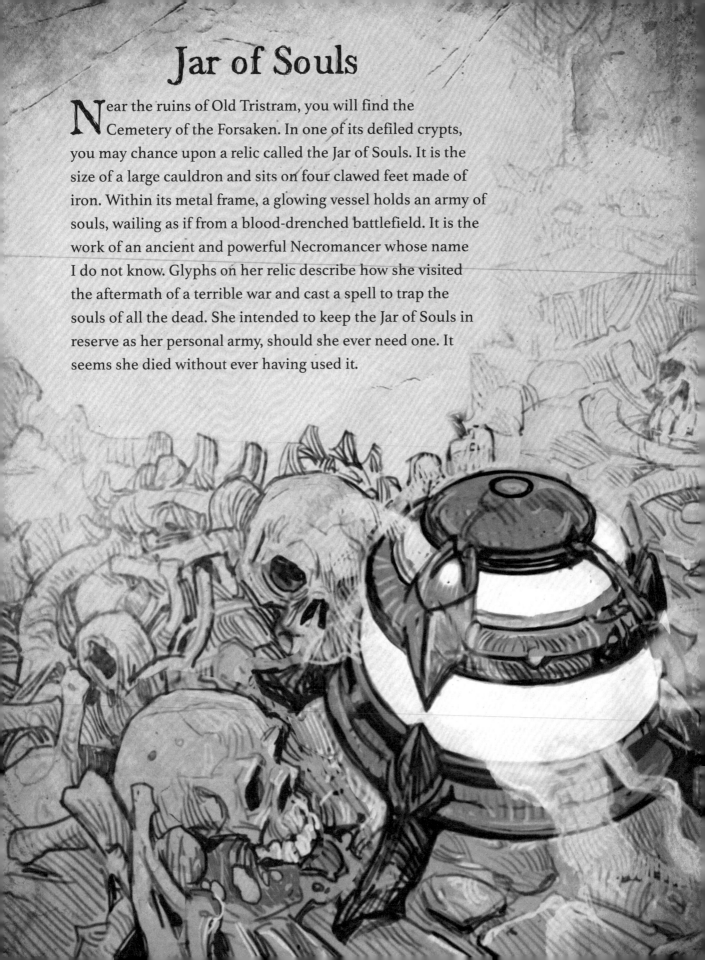

Near the ruins of Old Tristram, you will find the Cemetery of the Forsaken. In one of its defiled crypts, you may chance upon a relic called the Jar of Souls. It is the size of a large cauldron and sits on four clawed feet made of iron. Within its metal frame, a glowing vessel holds an army of souls, wailing as if from a blood-drenched battlefield. It is the work of an ancient and powerful Necromancer whose name I do not know. Glyphs on her relic describe how she visited the aftermath of a terrible war and cast a spell to trap the souls of all the dead. She intended to keep the Jar of Souls in reserve as her personal army, should she ever need one. It seems she died without ever having used it.

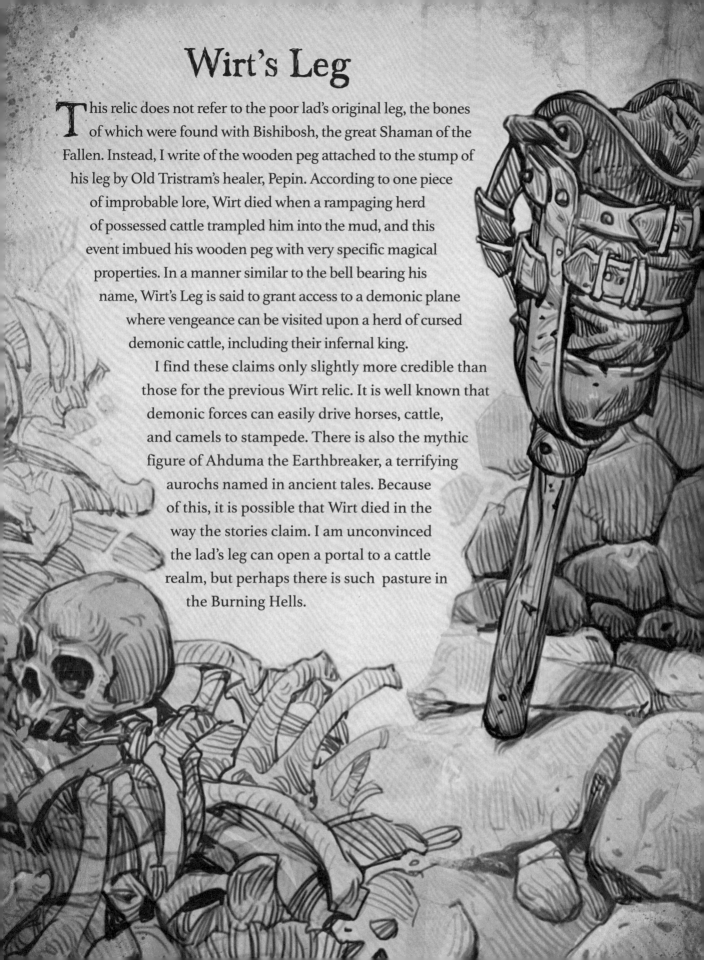

Wirt's Leg

This relic does not refer to the poor lad's original leg, the bones of which were found with Bishibosh, the great Shaman of the Fallen. Instead, I write of the wooden peg attached to the stump of his leg by Old Tristram's healer, Pepin. According to one piece of improbable lore, Wirt died when a rampaging herd of possessed cattle trampled him into the mud, and this event imbued his wooden peg with very specific magical properties. In a manner similar to the bell bearing his name, Wirt's Leg is said to grant access to a demonic plane where vengeance can be visited upon a herd of cursed demonic cattle, including their infernal king.

I find these claims only slightly more credible than those for the previous Wirt relic. It is well known that demonic forces can easily drive horses, cattle, and camels to stampede. There is also the mythic figure of Ahduma the Earthbreaker, a terrifying aurochs named in ancient tales. Because of this, it is possible that Wirt died in the way the stories claim. I am unconvinced the lad's leg can open a portal to a cattle realm, but perhaps there is such pasture in the Burning Hells.

Shield of Nahr

I began this text by acknowledging the dangers inherent in writing it, and the need to safeguard its contents from evil. I returned to Westmarch in pursuit of this purpose. I had hoped to find my father's kite shield, then enlist the skill of Charsi and the power of the Horadric Malus to reforge it. I succeeded in finding his shield. I was unsuccessful in locating Charsi. I hope she is well, wherever she may be. Her absence limited my options. There was only one other blacksmith I could trust with this work, and he died a long time ago.

Like much of Westmarch, my father's shop had been boarded up and abandoned for many years. I found the forge as cold as his grave. In that hallowed place, I used the same ritual Neyrelle had used to summon her mother, and I called forth the spirit of my father. ~~To stand before him after so much time, an older man than he was when I left him~~ We spoke, and I explained what I needed from him. He agreed to instruct me in the use of his forge and his tools.

For several days, I labored in the shop he had hoped to one day pass down to me. I lit the furnace and fanned the flames until I sweltered in the heat. My father instructed me how to reforge his shield using what I had learned from Kulle's <u>Arma Haereticorum</u>, and I brought forth my tokens.

I merged the water and earth in the Leaf of Glór-an-Fháidha with the fire of the Amethyst Ring. I added air from the Breath of Philios, and the fifth element of time housed in Radament's Hourglass. I bound these together in harmony and balance using the Scale of Rathma's Serpent. Lastly, I incorporated the courage and goodness in Meshif's pipe. ~~When it was complete, I told my father many things that~~ Then I bade my father a final farewell.

The product of our partnership does not possess the grace or beauty of more refined and noble workmanship, yet I know the magic in this new relic will serve my need. I have named it the Shield of Nahr, forged by father and son.

My dear Neyrelle,

I find I must write to you as I knew you, and as I hope to know you again. As the brilliant, brave, stubborn woman who dreamt of becoming Horadrim. To do otherwise is too painful.

I can't recall what I have said to you about my father, so forgive me if I repeat myself. Old men are allowed that luxury, are we not? I'm certain I must have at least mentioned that he was a soldier and a blacksmith.

My whole body aches from forging. I am sweaty and filthy. From that, I'm sure you have guessed that I have much to tell you, but not in a letter. For now, I will simply say that your use of the Ritual Tome inspired me, and I have just now gone back to add a note to you where I discuss that text in my book. There were things I needed to say to my father that I never said when he was alive. I think the burden of that had become buried and lost under everything else I have endured. That weight has lifted now, and I have you to thank for it.

I leave this letter on my father's anvil, though I dread the thought of you coming to Westmarch. I have already come far on this journey, and I am not done yet. I hope to see you again when we both can rest.

Lorath

I travel north with the Shield of Nahr upon my back. I leave behind my home. Much of my turmoil over Westmarch has been lifted. The city is less haunted. I could even see myself returning there to stay at the end of this journey. I will leave that decision for a future day.

I have entered the Sharval Wilds. In some ways, these forested lands remind me of the deep woods of Scosglen; in other ways, this is a far stranger place. The Zakarum faith still holds sway. It has come to a kind of truce with the old gods and myths that persist in the region's folk traditions. I wonder what will happen if the Cathedral of Light ever attempts to bring their demanding guidance to the people here . . .

In addition to the trees, the wolves here remind me of their brethren in Scosglen. I have just fought off a pack of them, and the Shield of Nahr served me well as an ordinary defense. For some reason, it pleases me that it has seen battle at least once.

The woods are thinning, and the hills are sloping. I am coming out of the Wilds into the steppes and wastes of the Dreadlands. I must tread carefully now. This may be the most hostile region in all of Sanctuary. The Children of Bul-Kathos have suffered unimaginable losses, and they are not what they once were. Many have forsaken their ancestral territory and migrated east. Those who remain retain their strength, even if it sleeps beneath a layer of ash. That is why I have come. So long as I can avoid the cannibal Unclean, I may leave these lands with my head still attached.

A song can sometimes be heard in the Dreadlands, howled from the ashes. It has no words, so I cannot quote it. The sound of it rattles the bones of all who hear it, a roar that bears the anguish and shame of the Children of Bul-Kathos. "The Lament of Ash," "Kanai's Lament," "Sescheron's Lament," all refer to the same primal expression of grief for everything the Northern Tribes have lost.

Malah's Thawing Potion

The Children of Bul-Kathos traditionally hold magic in disdain. There are some among the Barbarian tribes who practice it, especially the healing arts, which are highly valued after a bloody battle. Malah was the healer in the northern city of Harrogath during the siege of Baal, and the destruction caused by his demon forces tried her skills. It seemed to many the battle could not be won.

Nihlathak, the last living Elder of Harrogath, had secretly brokered a deal with Baal to spare the city. In exchange, Nihlathak gave the demon his people's most sacred Relic of the Ancients, which allowed the Prime Evil to access the Worldstone unhindered. When Anya, the daughter of another Harrogath Elder, discovered this pact and confronted Nihlathak, he imprisoned her in ice.

It was Malah who crafted the Thawing Potion that released Anya from her prison. This revealed Nihlathak's betrayal and made the defeat of Baal possible. When I contemplate the relic, a simple potion made by a virtuous healer, I am reminded that no effort in the battle against evil is wasted or unimportant. Despite what Malah believed about herself, were it not for her, all of Sanctuary may have fallen.

Soul Siphons

The ranks of the Burning Hells are endless. When one demon falls, a new evil rises to take its place. So it was that Skarn, Lord of Damnation, came to power and threatened Sanctuary.

Deep within his realm, he devised a method to extract the essence from living angels. He called these monstrous torture devices Soul Siphons. Their corrosive, grasping tentacles burrowed relentlessly into their victim, piercing armor and all defenses, until they reached the angel's core. Then they began to slowly suck out the angel's essence, a process kept excruciatingly slow to cause prolonged suffering and to allow the Siphon time to safely absorb the harmful angelic light. Skarn used the energy extracted from an entire legion of angels to open the Pits of Anguish and call forth an army to rival the forces of the Prime and Lesser Evils. He planned to invade Sanctuary and extract the soul of every human, but he was defeated by a noble hero with the help of Deckard Cain.

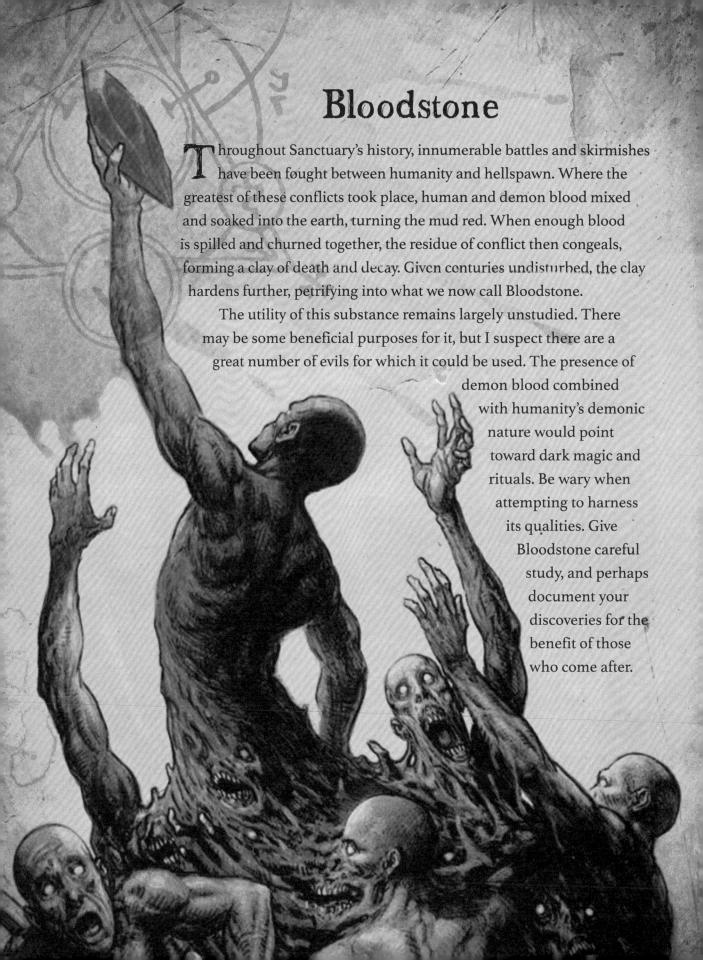

Bloodstone

Throughout Sanctuary's history, innumerable battles and skirmishes have been fought between humanity and hellspawn. Where the greatest of these conflicts took place, human and demon blood mixed and soaked into the earth, turning the mud red. When enough blood is spilled and churned together, the residue of conflict then congeals, forming a clay of death and decay. Given centuries undisturbed, the clay hardens further, petrifying into what we now call Bloodstone.

The utility of this substance remains largely unstudied. There may be some beneficial purposes for it, but I suspect there are a great number of evils for which it could be used. The presence of demon blood combined with humanity's demonic nature would point toward dark magic and rituals. Be wary when attempting to harness its qualities. Give Bloodstone careful study, and perhaps document your discoveries for the benefit of those who come after.

Eye of Etlich

During the time of the crusade by Rakkis against the northern tribes, a corpse emerged from the ice on the slopes of Mount Arreat. It did not appear to be one of the Children of Bul-Kathos. Its leathery skin bore strange tattoos, and the style of its clothing resembled no people the Barbarians knew of. They called it Etlich, which is said to mean "stranger" in some lost tongue. Given the frozen conditions, it was impossible to guess the age of the corpse. Many believe it had come to rest there before the Sin Wars, and perhaps even earlier, during the ancient days of the Firstborn. It was this that led some to believe the body held power, and indeed it did. One of its eyes ended up encased in an amulet, the Eye of Etlich, a powerful relic that granted its wearer the ability to see and avoid the missiles of ranged attacks. It is now commonly held that Etlich must have been a mighty mage who wielded the power of a dozen sorcerers. What happened to the rest of his corpse remains a mystery.

Hellfire Ring

As with the Token of Absolution, the creation of this relic is an arduous endeavor. The process begins with Infernal Machines, devices composed of intricate magical gears that open portals to hostile planes. Those who venture there describe battles against more lethal versions of enemies they have already vanquished.

If they return from these confrontations victorious, they sometimes bring with them the ingredients necessary to forge a Hellfire Ring. The result is a grim band made of bone and spine, crowned with a sharp demon's tooth and a baleful eye.

Those who wear these rings find all their faculties sharpened, such that they learn new skills with much greater ease, and none can deny the bravery of one who wears a Hellfire Ring.

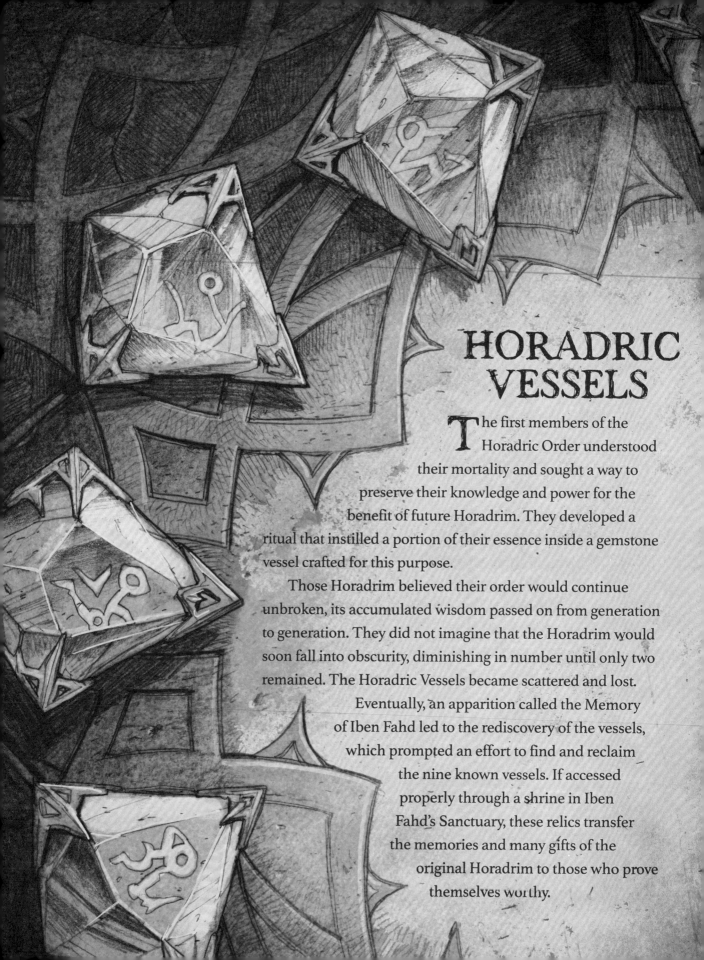

HORADRIC VESSELS

The first members of the Horadric Order understood their mortality and sought a way to preserve their knowledge and power for the benefit of future Horadrim. They developed a ritual that instilled a portion of their essence inside a gemstone vessel crafted for this purpose.

Those Horadrim believed their order would continue unbroken, its accumulated wisdom passed on from generation to generation. They did not imagine that the Horadrim would soon fall into obscurity, diminishing in number until only two remained. The Horadric Vessels became scattered and lost.

Eventually, an apparition called the Memory of Iben Fahd led to the rediscovery of the vessels, which prompted an effort to find and reclaim the nine known vessels. If accessed properly through a shrine in Iben Fahd's Sanctuary, these relics transfer the memories and many gifts of the original Horadrim to those who prove themselves worthy.

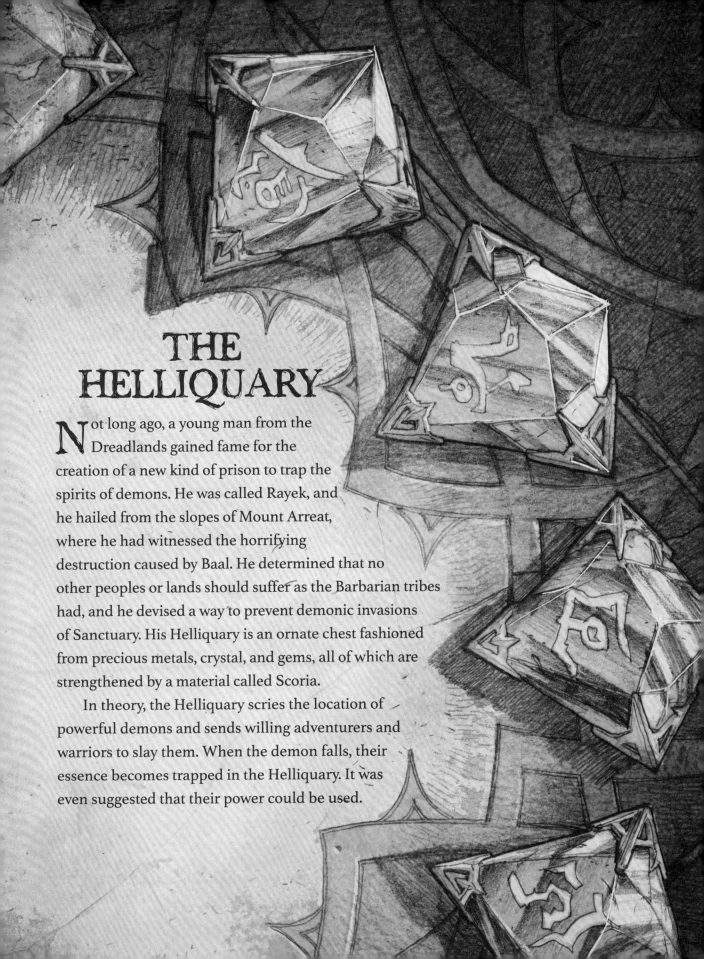

THE HELLIQUARY

Not long ago, a young man from the Dreadlands gained fame for the creation of a new kind of prison to trap the spirits of demons. He was called Rayek, and he hailed from the slopes of Mount Arreat, where he had witnessed the horrifying destruction caused by Baal. He determined that no other peoples or lands should suffer as the Barbarian tribes had, and he devised a way to prevent demonic invasions of Sanctuary. His Helliquary is an ornate chest fashioned from precious metals, crystal, and gems, all of which are strengthened by a material called Scoria.

In theory, the Helliquary scries the location of powerful demons and sends willing adventurers and warriors to slay them. When the demon falls, their essence becomes trapped in the Helliquary. It was even suggested that their power could be used.

Scepter of Fahir

Like the Horadric Staff, the Scepter of Fahir was divided into three pieces and then buried in hidden tombs beneath the sand. Unlike the Horadric Staff, the Scepter of Fahir possessed no powers beyond its strength as a symbol to the desert people of the Shassar Sea. Fahir was a merciless tyrant, a mortal human who called himself a god. His atrocities and depravities were demonic, including human sacrifice in his name. Upon his death, the people rejoiced and broke the scepter that had been a symbol of his rule. Conflict swept across the sands as armed factions vied for scraps of power. One violent militia, the Sand Scorpions, abused the people and seemed no better than Fahir. The Amber Blades opposed them. Their leader, Tabri, believed that if she could recover the Scepter of Fahir, she could use it to unite the Shassar Sea behind her and rule a different way than Fahir. Many tyrants have promised the same.

Magical or not, I believe this relic might be cursed.

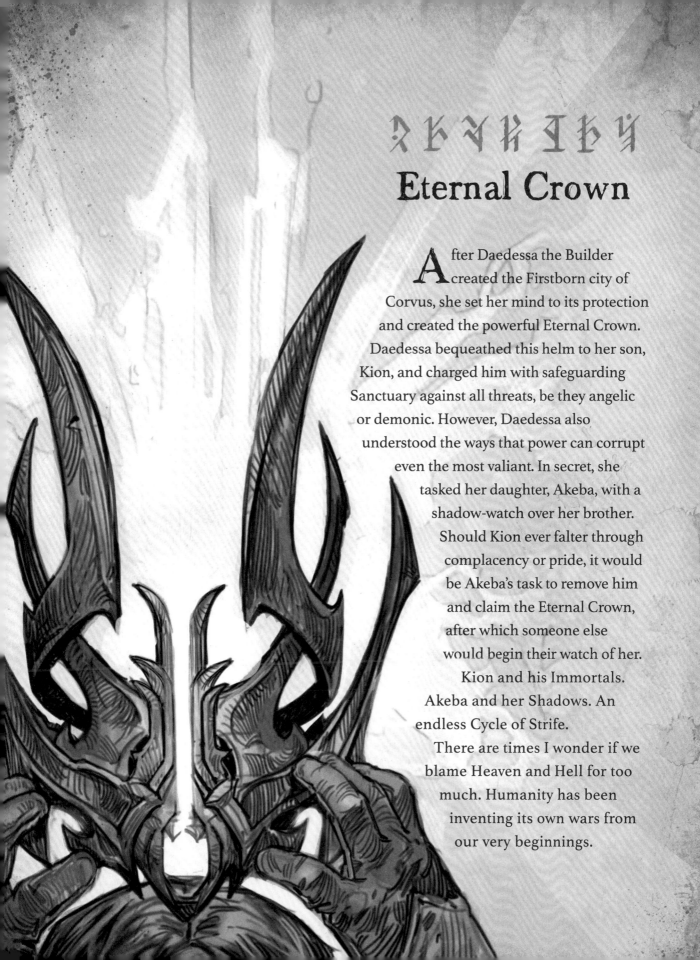

Eternal Crown

After Daedessa the Builder created the Firstborn city of Corvus, she set her mind to its protection and created the powerful Eternal Crown. Daedessa bequeathed this helm to her son, Kion, and charged him with safeguarding Sanctuary against all threats, be they angelic or demonic. However, Daedessa also understood the ways that power can corrupt even the most valiant. In secret, she tasked her daughter, Akeba, with a shadow-watch over her brother. Should Kion ever falter through complacency or pride, it would be Akeba's task to remove him and claim the Eternal Crown, after which someone else would begin their watch of her. Kion and his Immortals. Akeba and her Shadows. An endless Cycle of Strife.

There are times I wonder if we blame Heaven and Hell for too much. Humanity has been inventing its own wars from our very beginnings.

Crown & Fang of Fernam

Centuries ago, a lord of Gea Kul became so obsessed with the attainment of immortality that he looked to vampires in his quest to find a cure for death. For years, his mages and scholars conducted forbidden experiments and developed dark rituals, but they failed to deliver their lord what he sought. Eventually, he ordered a vampire beast captured and brought to the catacombs beneath his castle, an act of hubris with lethal results. The vampire escaped and slew the lord, along with most of his guard. The only man to survive the attack was a soldier called Fernam, but he had been infected by the vampire's curse. One of the lord's mages performed a ritual to preserve what he could of Fernam's humanity, transforming him into something neither fully human nor vampire: the first Blood Knight.

The same ritual has since been used to create other Blood Knights through the years. In fact, there exists a brotherhood of such beings, though they are highly secretive, and I know little about them. I cannot blame them for keeping to the shadows, given the widespread mistrust of their vampiric origins. Yet could the same things not be said of humanity's demonic parentage? Surely by now we know something of contradicting natures.

The Crown of Fernam is a golden crest, taken, I assume, from the lord whose actions changed Fernam into what he became. Worn upon the head, it represents the wisdom and knowledge of the rational human mind and will. The Fang of Fernam is a cruel and ravenous spear, a blade of steel with an unquenchable, animal thirst for blood. Taken together, these two relics of the first Blood Knight represent the duality that exists within these beings. *And also, perhaps, the duality that exists in each of us.*

Gibbering Gemstone

ᚠᛁᚦᚨᚢᚱᛞᛖ�ᛦ

On the slopes of Mount Arreat, there was a delve called the Caverns of Frost. Among the Icy Quillbacks and Frostclaw Burrowers that infested its tunnels, there were lacuni to contend with. One was in possession of a relic known as the Gibbering Gemstone. I mention it only because of its prominence in tales, not because of its potency or properties. In fact, the sources and texts I've read suggest this gemstone does absolutely nothing. Rather, it seems to be well known primarily for its association with Wirt's Bell and the Staff of Herding.

Necromancer's Shovel

The village of Middlewick suffered in much the same ways other townships suffered at the hands of the Zakarum church. By the time Bishop Stretvanger left with his militia, half the cottages and hovels had burned down and a dozen villagers had been murdered, along with two Zakarum soldiers. What set Middlewick apart were the seven undead corpses that tore apart a young girl named Dalya before doing the same to the soldier who went looking for her in the cellar. Upon realizing the danger, Stretvanger burned the cottage down on top of them, which might have covered up the whole affair. However, there were too many witnesses. And there was the shovel.

It had a long black shaft carved with glyphs and runes and a narrow ivory blade etched with swirling vegetal patterns. It was a Necromancer's tool for safely exhuming corpses from the ground, and it was found in the woods, having been used to almost decapitate another Zakarum militiaman. An uncommon implement to find in a place like Middlewick. Someone in that village carried dark and heavy secrets, most likely to the grave.

Rygnar Idol

This is a strange relic. At first glance, it would appear to be a Necromancer Totem, in that it contains a human skull. I have never seen a Priest of Rathma using anything like it. The bone has been entirely gilded, then embossed with runes and glyphs, refining its appearance in a way that seems inconsistent with Necromancer purposes. It was unearthed in a desert tomb in Kehjistan, surrounded by undead skeletal guardians. Its chamber offered no clues about its origins or purpose. Of greater significance, perhaps, is the rumor that it was once in possession of Zoltun Kulle.

Kulle did not waste time on lesser magic, or lesser artifacts. If he took interest in the Rygnar Idol, it would likely be worth investigating should it come within your reach.

Kanai's Cube

I have already discussed this relic in relation to the Horadric Cube. What I have not mentioned of Chief Elder Kanai is its namesake. After the Horadrim made the decision to hide the cube, they needed a guardian with strength and honor to defend it, and to find such a person, they looked to the north, to the stronghold of Sescheron. It speaks very highly of Kanai that out of all humanity, the Horadrim entrusted him with the cube's safekeeping.

Kanai fell in the destruction of his city by the armies of Baal, and his people felt his loss profoundly. The Children of Bul-Kathos have only ever recognized two leaders as kings worthy enough to sit upon the Immortal Throne. Had Kanai lived, he may have one day attained that position. His people chose to grant him that honor in death by placing his body upon the throne, somehow still formidable even in death.

That is the strength of the Northern Tribes, the strength in the Children of Bul-Kathos, which draws from the strength of Sanctuary itself. I need that behind my shield if I am to safeguard my book.

Raekor's Resolve

ᛁᛦᛁᛯᛁ

Raekor was another warrior of great renown among the Northern Tribes, the first woman in their history to be appointed Warmaster. She earned this honor through her courage, ferocity, and strength in defending her people against the encroachment of surrounding empires. Her armor is a set of relics on its own. I have come here seeking an amulet bearing her name.

This relic's legend tells of a battle in which Raekor tumbled down a steep embankment into a riverbed, where she was cut off from her forces. Enemy Saumurenians surrounded her, and she quickly realized she had lost her weapons in the fall. Rather than surrender, she picked up two great river rocks. One she used as a shield; the other she used to bash her enemies' skulls. So ferociously did she fight that each blow she gave and each strike she deflected chipped away at the rocks. By the time her own warriors reached her, she had slain most of the Saumurenians and only one of the rocks remained in her hand, now reduced to the size of a pebble.

One of her men took that rock and turned it into an amulet to commemorate her strength and resolve in the face of almost certain defeat. That is a quality of resolve I aspire to in my own confrontations with evil.

I have retrieved Raekor's stone. It was where my research said it would be, unmarked and unprotected. A deeply tragic sign of how much the Children of Bul-Kathos have lost and how far they have fallen. I almost feel guilty taking it. I intend to use it for something that will honor Raekor more than she would be if I were to leave the amulet where I found it.

Now I head east to Xiansai.

─────────────

The Dreadlands are unlike anything I have seen or experienced. I find them as unsettling as the Burning Hells, in their own way. There is an absence here. A profound void. At first, I couldn't figure out why I felt so disturbed. I thought it might just be my fear of some nameless threat that could defeat me when I am so close to the end of this journey. Then I realized what it was. I had traveled miles without seeing another living thing. Not a bird. Not a plant. Not even a cockroach. Instead, this is the land that grows Barbarians and Demon Hunters. I think I better understand both types of warriors.

─────────────

I will stop in Ivgorod. I hope to see Neyrelle there. She mentioned perhaps staying for a time with the monks of the Floating Sky Monastery, if they will have her. She wondered if their mental training might help her resist the influence of Mephisto. I am choosing to hope that is the case.

─────────────

These Tamoe Mountains are harsher than the Fractured Peaks, which I would not have thought possible. They are sharper somehow. I am wearing Donan's fur cloak again, the reason I carried it with me all this way. The icy wind finds a way to cut through it. I cannot understand why anyone would choose this place for a monastery. I will arrive there soon, and I hope they serve something hot to drink.

Hello there, old man,

If you are reading this, then I might have become a seer since you last saw me. When I left the other letters for you, I thought there was maybe a chance you would find them. But up here? At the top of the world? Not a chance at all. I had this dream, you see. I saw you walking east through miles and miles of ash. I figured that had to be the Dreadlands, which meant you were heading this way. That's why I'm writing this letter. And it's also why I'm leaving.

Don't be angry. Well, I know you'll probably be angry. Please don't be hurt. I'm doing this to protect you. I was honestly planning to leave anyway. I've learned as much as I can from the monks here, and I think their techniques are helping me to ignore the voices and the visions. I am doing much better than I was. I also worry about staying too long in one place. It's better for me to be alone. And selfish of me to seek the company of others, with the burden I carry.

I don't know where I will go from here. I only know that I can't let anything happen to you. I've lost too much already. If you got hurt because of me, I think that would destroy me.

Goodbye, old man.

Neyrelle

She was here. Only days ago. One of the masters spent time with her. His voice trembled with fear as he spoke. And he was one of the few who would go near her to teach her. He said she is an agent of pure chaos and hatred, even though she clearly doesn't want to be. The monks never even let her into the monastery. They made her sleep in a guest hut far outside the walls. I don't blame them. I fear I am losing her, ~~or perhaps she is already lost~~

I need to find her. No one knows which way she traveled. So now I have a decision to make. Do I go searching for her? Or do I finish what I started with my book?

I don't know what to do.

———

I have wasted two days in pointless rumination. Days I could have spent looking for her or pressing east. Instead, I am here, losing time. I must leave tomorrow. I have until dawn to decide which path I will take.

———

I am heading east.

I am choosing faith.

The book is for Neyrelle, and it must be finished and ready for her. If not her, it must be ready for others. Though I must believe it is for her.

———

Tomorrow, I begin my final descent out of the mountains. I can see the ocean from where I sit. I think I can even see Xiansai in the distance. I might be imagining it. This last stage of my journey is the riskiest—not for myself, but for the book. If this fails, then everything I have done, all the miles I have traveled and the words I have written, will have been for naught. At times like this, I wish I prayed.

Neyrelle,

I am not angry with you, child. I was hurt. That was simply my pride, and the moment has passed. Now that you are gone from the monastery, I doubt you will return, so I don't know where I will leave this letter. I think it will stay in the book until you are able to read it.

I have come to the end of my journey. I am sitting on a terrace in a coastal town on Xiansai, overlooking a bay. A much better welcome than I received from the Askari. Mages have been coming here from the Yshari Sanctum for generations, so outsiders are not unheard of, and the Horadrim are still respected. For now.

I am not sure how long it will take to find the spell or device that will suit my needs. If it can be found anywhere, it will be on Xiansai. Deckard Cain said these mountains are littered with arcane repositories. Surely one of them will hold the answer.

By now you are probably feeling impatient for me to just come out with it and explain what the hell I'm talking about. And I will. But not in this letter. The book will explain it when you read it.

As soon as I am done with this island, I am coming to you. No matter where you are, I will find you, and I will help you. If that is the last thing I do, my head will go to the Tree of Whispers wearing a smile.

Lorath

"Given time, even a mountain will bow to the rain."

I have heard this expression spoken by travelers from Xiansai. It is often used in a general way to describe the impermanence of things, but I believe it is intended to have many meanings.

We come to the end.

I have traveled from one end of the world to the other. I have journeyed backward through my own footsteps, through time, revisiting places and memories, until at last I came home to the place of my birth to finally reckon with my ghosts.

Now I am here on Xiansai, an island I never imagined I would see, and my contact has found what I needed. I will not name her, since I am not familiar with the customs here, and she implied that she had to break some rules to help me. I am extremely humbled and grateful for her aid, and do not wish to get her into any trouble on my account.

The relic she provided me is called Rin's Conduit. It consists of two bowls connected by a thick, braided cord of golden wire. The bowls appear to be carved from ivory or bone, covered in finely detailed rows of glyphs I don't recognize. The conduit facilitates a transfer of essence—and not in the cruel and extractive way of the Soul Siphons. It is a gentle, voluntary process. In fact, I believe this device was created for healing and medicine, allowing a strong, healthy individual to transfer some of their essence to the sick or injured.

I used it to transfer the magical essences of the Shield of Nahr and Raekor's Resolve into special glyphs I created for this book. In doing so, I have created the strongest protection wards within my skill, and I have placed them at the beginning and the end of this tome. If you are reading this, you already saw the first glyph. The second will come at the end, after I have finished writing.

All text that lies between the two is protected.

beyond my skill, actually

I know the spell I crafted is unconventional. I know there were and are more traditional wards available. I don't want to keep doing what has already been done. That can only achieve the results we have already obtained. Wards and Soulstones will inevitably break. Vaults will be opened. Libraries will be burned or seized. Codes will be deciphered.

I hope the spell I have used to bind the pages of this book will last.

If I have succeeded, and I believe I have, the armor of the Shield of Nahr, backed by Raekor's Resolve, will keep evil away from this book. To those with demonic or dark intent, its contents will be incomprehensible, impenetrable, inviolable. That means if you are reading this, you have been judged worthy by the magic I have put in place. That does not mean you are perfect. (Remember that all humans have within them shades of the demonic and the divine.) It means that within you, good is currently winning your personal Eternal Conflict, and nothing more can be asked of us than that.

The same applies to you, Neyrelle. I wrote this book for you more than anyone. After the Cathedral of Light cleared out the Vault that you and your mother spent so much time trying to find, I knew you would need a first volume to start your own library. Let this be it.

Now I must be honest with you. After the decision you made, that brave, terrible, inevitable choice, I had to find a way to be sure of you. With the burden you carry, I could not risk you becoming another Elias, or worse. I know you understand this, perhaps better than anyone else could. I also think that after your ordeal, there will be timcs when you will need to be sure of yourself. The protections I have placed around this book can therefore satisfy both of us. If you are reading this, then you have done something unheard of in the history of Sanctuary. You have carried a Soulstone containing a Prime Evil without succumbing to its influence. There can be no doubt of your strength and your goodness.

You are still Neyrelle.

You are something more than Horadrim.

—*Lorath*

Published by Blizzard Entertainment.

This book is a work of fiction. Names, characters, places, and incidents are either products of the author's imagination or are used fictitiously, and any resemblance to actual persons, living or dead, business establishments, events, or locales is entirely coincidental.

Additional Art: siloto/stock.adobe.com (10) · Vagengeim/stock.adobe.com (3-7, 9, 48-49, 54-56, 83, 90, 92, 93, 95, 98, 108-109, 116, 118-119, 130-131, 136-141, 144, 153, 164, 168-171, 173) · Scisetti Alfio/stock.adobe.com (8, 43) · sveta/stock.adobe.com (48-49, 55, 67-68, 121-123, 133, 149-150, 167-170) · Coffeechocolates/stock.adobe.com (8-9) · LiliGraphie/stock.adobe.com (2, 104) · Nik_Merkulov/stock.adobe.com (79, 153-154) · Savvapanf Photo ©/stock.adobe.com (105, 115, 162-163, 165) · Taviphoto/stock.adobe.com (70, 72-75, 77, 80-82, 85-86, 88-91) · Lumos sp/stock.adobe.com (50) · Airin/stock.adobe.com (7, 33, 35, 43) · artistmef/stock.adobe.com (25, 55-56) · ish_imp_photos/stock.adobe.com (78) · Tony Baggett/stock.adobe.com (29)

Library of Congress Cataloging-in-Publication Data available.

ISBN: 978-1-956916-14-0

Manufactured in China

Print run 10 9 8 7 6 5 4 3 2 1

BOOK OF LORATH

Written by: MATTHEW J. KIRBY

Illustrated by:

 JEAN BAPTISTE MONGE: Cover

 FRANCESCA BAERALD: 2

 CHRIS BOLTON: 30, 31, 154

 ZOLTAN BOROS: 4, 27, 44, 45, 54, 56, 70, 71, 99, 138, 139, 142, 146, 147, 159

 MICHAEL CHAE: 8, 9

 TUNCER EREN: 112, 113

 SAM GAO, HUNTER HYLTIN, NICK MURANO: 104

 IGOR KRSTIC: 16, 17, 26, 28, 35, 38, 39, 40, 42, 61, 72, 80, 81, 86, 87, 92, 93, 103, 143

 JOSEPH LACROIX: 7, 12, 13, 14, 15, 18, 19, 20, 21, 52, 53, 60, 62, 63, 94, 108, 110, 111, 118, 126, 127, 131, 137, 152, 155, 160, 162, 172, 173, 174, 175

 GARY LAIB: 58, 59, 64, 65, 84, 85, 98

 SEAN A. MURRAY: 22, 23, 33, 34, 41, 46, 51, 57, 66, 73, 88, 97, 101, 106, 116, 117, 120, 124, 125, 128, 132, 148, 155, 156, 157, 158, 166

 HENRIK ROSENBORG: 24, 25, 32, 36, 37, 76, 77, 100

Edited by: ERIC GERON

Design by: COREY PETERSCHMIDT

Produced by: BRIANNE MESSINA, AMBER THIBODEAU

Lore Consultation by: JUSTIN PARKER

Game Team Consultation: JON DAWSON, ROD FERGUSSON, JOHN MUELLER, RAFAŁ PRASZCZALEK, ASHTON SANDERSON, JOE SHELY, MAC SMITH

Special Thanks: MICHAEL BYBEE, ELANA COHEN, ERIN FUSCO, KIERSTEN VANNEST

BLIZZARD ENTERTAINMENT

Director, Consumer Products, Publishing: BYRON PARNELL

Associate Publishing Manager: DEREK ROSENBERG

Director, Manufacturing: ANNA WAN

Senior Director, Story and Franchise & Development: DAVID SEEHOLZER

Senior Producer, Books: BRIANNE MESSINA

Associate Producer, Books: AMBER THIBODEAU

Editorial Supervisor: CHLOE FRABONI

Senior Editor: ERIC GERON

Book Art & Design Manager: COREY PETERSCHMIDT

Historian Supervisor: SEAN COPELAND

Associate Producer, Lore: ED FOX

Associate Historians: MADI BUCKINGHAM, COURTNEY CHAVEZ, DAMIEN JAHRSDOERFER, IAN LANDA-BEAVERS

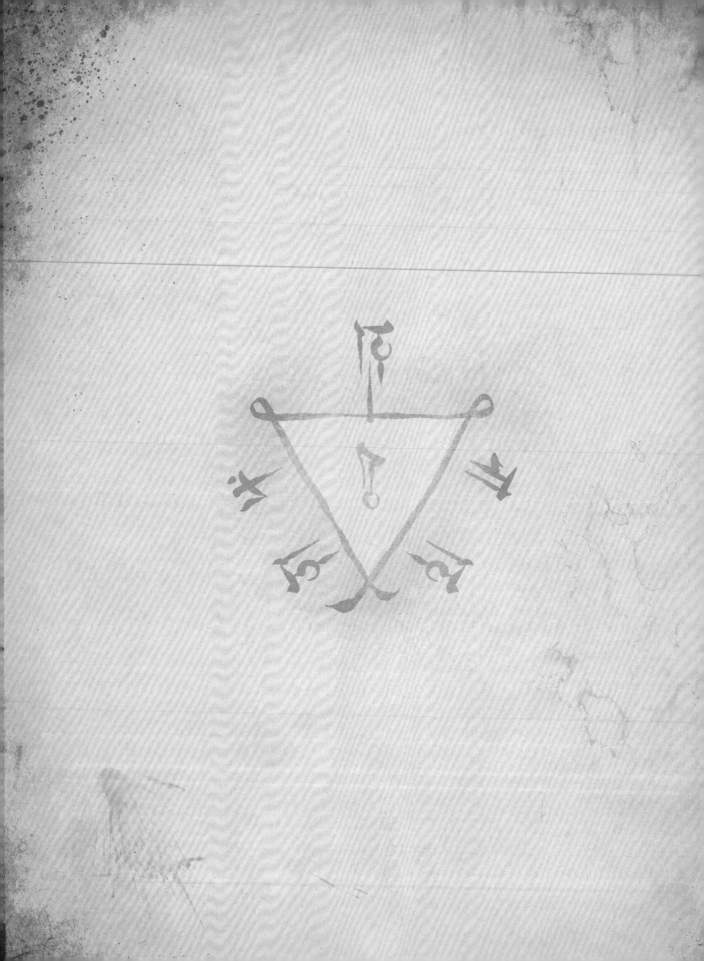